Francis Frith's
Kent

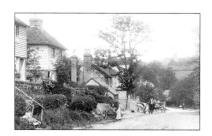

Photographic Memories

Francis Frith's
Kent

Revised edition of original work by

Helen Livingston

First published in the United Kingdom in 1999
by WBC Ltd

Hardback Reprinted in 2000
ISBN 1-85937-276-7

British Library Cataloguing in Publication Data

Francis Frith's Kent
Helen Livingston

Frith Book Company Ltd
Frith's Barn, Teffont,
Salisbury, Wiltshire SP3 5QP
Tel: +44 (0) 1722 716 376
Email: info@frithbook.co.uk
www.frithbook.co.uk

Printed and bound in Great Britain

Front cover: Rochester, High Street 1908 59875

AS WITH ANY HISTORICAL DATABASE THE FRITH ARCHIVE IS CONSTANTLY BEING CORRECTED AND IMPROVED
AND THE PUBLISHERS WOULD WELCOME INFORMATION ON OMISSIONS OR INACCURACIES

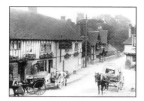

Contents

Francis Frith: *Victorian Pioneer*

FRANCIS FRITH, Victorian founder of the world-famous photographic archive, was a complex and multitudinous man. A devout Quaker and a highly successful Victorian businessman, he was both philosophic by nature and pioneering in outlook.

By 1855 Francis Frith had already established a wholesale grocery business in Liverpool, and sold it for the astonishing sum of £200,000, which is the equivalent today of over £15,000,000. Now a multi-millionaire, he was able to indulge his passion for travel. As a child he had pored over travel books written by early explorers, and his fancy and imagination had been stirred by family holidays to the sublime mountain regions of Wales and Scotland. 'What a land of spirit-stirring and enriching scenes and places!' he had written. He was to return to these scenes of grandeur in later years to 'recapture the thousands of vivid and tender memories', but with a different purpose. Now in his thirties, and captivated by the new science of photography, Frith set out on a series of pioneering journeys to the Nile regions that occupied him from 1856 until 1860.

Intrigue and Adventure

He took with him on his travels a specially-designed wicker carriage that acted as both dark-room and sleeping chamber. These far-flung journeys were packed with intrigue and adventure. In his life story, written when he was sixty-three, Frith tells of being held captive by bandits, and of fighting 'an awful midnight battle to the very point of surrender with a deadly pack of hungry, wild dogs'. Sporting flowing Arab costume, Frith arrived at Akaba by camel seventy years before Lawrence, where he encountered 'desert princes and rival sheikhs, blazing with jewel-hilted swords'.

During these extraordinary adventures he was assiduously exploring the desert regions bordering the Nile and patiently recording the antiquities and peoples with his camera. He was the first photographer to venture beyond the sixth cataract. Africa was still the mysterious 'Dark Continent', and Stanley and Livingstone's historic meeting was a decade into the future. The conditions for picture taking confound belief. He laboured for hours in his wicker dark-room in the sweltering heat of the desert, while the volatile chemicals fizzed dangerously in their trays. Often he was forced to work in remote tombs and caves where conditions were cooler. Back in London he exhibited his photographs and was

'rapturously cheered' by members of the Royal Society. His reputation as a photographer was made overnight. An eminent modern historian has likened their impact on the population of the time to that on our own generation of the first photographs taken on the surface of the moon.

Venture of a Life-Time

Characteristically, Frith quickly spotted the opportunity to create a new business as a specialist publisher of photographs. He lived in an era of immense and sometimes violent change. For the poor in the early part of Victoria's reign work was a drudge and the hours long, and people had precious little free time to enjoy themselves. Most had no transport other than a cart or gig at their disposal, and had not travelled far beyond the

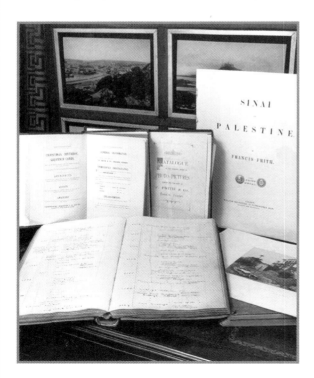

boundaries of their own town or village. However, by the 1870s, the railways had threaded their way across the country, and Bank Holidays and half-day Saturdays had been made obligatory by Act of Parliament. All of a sudden the ordinary working man and his family were able to enjoy days out and see a little more of the world.

With characteristic business acumen, Francis Frith foresaw that these new tourists would enjoy having souvenirs to commemorate their days out. In 1860 he married Mary Ann Rosling and set out with the intention of photographing every city, town and village in Britain. For the next thirty years he travelled the country by train and by pony and trap, producing fine photographs of seaside resorts and beauty spots that were keenly bought by millions of Victorians. These prints were painstakingly pasted into family albums and pored over during the dark nights of winter, rekindling precious memories of summer excursions.

The Rise of Frith & Co

Frith's studio was soon supplying retail shops all over the country. To meet the demand he gathered about him a small team of photographers, and published the work of independent artist-photographers of the calibre of Roger Fenton and Francis Bedford. In order to gain some understanding of the scale of Frith's business one only has to look at the catalogue issued by Frith & Co in 1886: it runs to some 670 pages, listing not only many thousands of views of the British Isles but also many photographs of most European countries, and China, Japan, the USA and

Canada – note the sample page shown above from the hand-written *Frith & Co* ledgers detailing pictures taken. By 1890 Frith had created the greatest specialist photographic publishing company in the world, with over 2,000 outlets – more than the combined number that Boots and WH Smith have today! The picture on the right shows the *Frith & Co* display board at Ingleton in the Yorkshire Dales. Beautifully constructed with mahogany frame and gilt inserts, it could display up to a dozen local scenes.

Postcard Bonanza

The ever-popular holiday postcard we know today took many years to develop. In 1870 the Post Office issued the first plain cards, with a pre-printed stamp on one face. In 1894 they allowed other publishers' cards to be sent through the mail with an attached adhesive halfpenny stamp. Demand grew rapidly, and in

1895 a new size of postcard was permitted called the court card, but there was little room for illustration. In 1899, a year after Frith's death, a new card measuring 5.5 x 3.5 inches became the standard format, but it was not until 1902 that the divided back came into being, with address and message on one face and a full-size illustration on the other. *Frith & Co* were in the vanguard of postcard development, and Frith's sons Eustace and Cyril continued their father's monumental task, expanding the number of views offered to the public and recording more and more places in Britain, as the coasts and countryside were opened up to mass travel.

Francis Frith died in 1898 at his villa in Cannes, his great project still growing. The archive he created continued in business for another seventy years. By 1970 it contained over a third of a million pictures of 7,000 cities, towns and villages. The massive photographic record Frith has left to us stands as a living monument to a special and very remarkable man.

Frith's Archive: *A Unique Legacy*

FRANCIS FRITH'S legacy to us today is of immense significance and value, for the magnificent archive of evocative photographs he created provides a unique record of change in 7,000 cities, towns and villages throughout Britain over a century and more. Frith and his fellow studio photographers revisited locations many times down the years to update their views, compiling for us an enthralling and colourful pageant of British life and character.

We tend to think of Frith's sepia views of Britain as nostalgic, for most of us use them to conjure up memories of places in our own lives with which we have family associations. It often makes us forget that to Francis Frith they were records of daily life as it was actually being lived in the cities, towns and villages of his day. The Victorian age was one of great and often bewildering change for ordinary people, and

though the pictures evoke an impression of slower times, life was as busy and hectic as it is today.

We are fortunate that Frith was a photographer of the people, dedicated to recording the minutiae of everyday life. For it is this sheer wealth of visual data, the painstaking chronicle of changes in dress, transport, street layouts, buildings, housing, engineering and landscape that captivates us so much today. His remarkable images offer us a powerful link with the past and with the lives of our ancestors.

Today's Technology

Computers have now made it possible for Frith's many thousands of images to be accessed almost instantly. In the Frith archive today, each photograph is carefully 'digitised' then stored on a CD Rom. Frith archivists can locate a single photograph amongst thousands within seconds. Views can be catalogued and sorted under a variety of categories of place and content to the immediate benefit of researchers.

Inexpensive reference prints can be created for them at the touch of a mouse button, and a wide range of books and other printed materials assembled and published for a wider, more general readership - in the next twelve months over a hundred Frith local history titles will be published! The day-to-day workings of the archive are very different from how they were in Francis Frith's time: imagine the herculean task of sorting through eleven tons of glass negatives as Frith had to do to locate a particular

See Frith at www. frithbook.co.uk

sequence of pictures! Yet the archive still prides itself on maintaining the same high standards of excellence laid down by Francis Frith, including the painstaking cataloguing and indexing of every view.

It is curious to reflect on how the internet now allows researchers in America and elsewhere greater instant access to the archive than Frith himself ever enjoyed. Many thousands of individual views can be called up on screen within seconds on one of the Frith internet sites, enabling people living continents away to revisit the streets of their ancestral home town, or view places in Britain where they have enjoyed holidays. Many overseas researchers welcome the chance to view special theme selections, such as transport, sports, costume and ancient monuments.

We are certain that Francis Frith would have heartily approved of these modern developments in imaging techniques, for he himself was always working at the very limits of Victorian photographic technology.

The Value of the Archive Today

Because of the benefits brought by the computer, Frith's images are increasingly studied by social historians, by researchers into genealogy and ancestry, by architects, town planners, and by teachers and schoolchildren involved in local history projects.

In addition, the archive offers every one of us an opportunity to examine the places where we and our families have lived and worked down the years. Highly successful in Frith's own era, the archive is now, a century and more on, entering a new phase of popularity.

The Past in Tune with the Future

Historians consider the Francis Frith Collection to be of prime national importance. It is the only archive of its kind remaining in private ownership and has been valued at a million pounds. However, this figure is now rapidly increasing as digital technology enables more and more people around the world to enjoy its benefits.

Francis Frith's archive is now housed in an historic timber barn in the beautiful village of Teffont in Wiltshire. Its founder would not recognize the archive office as it is today. In place of the many thousands of dusty boxes containing glass plate negatives and an all-pervading odour of photographic chemicals, there are now ranks of computer screens. He would be amazed to watch his images travelling round the world at unimaginable speeds through network and internet lines.

The archive's future is both bright and exciting. Francis Frith, with his unshakeable belief in making photographs available to the greatest number of people, would undoubtedly approve of what is being done today with his lifetime's work. His photographs, depicting our shared past, are now bringing pleasure and enlightenment to millions around the world a century and more after his death.

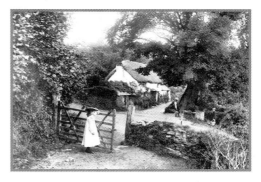

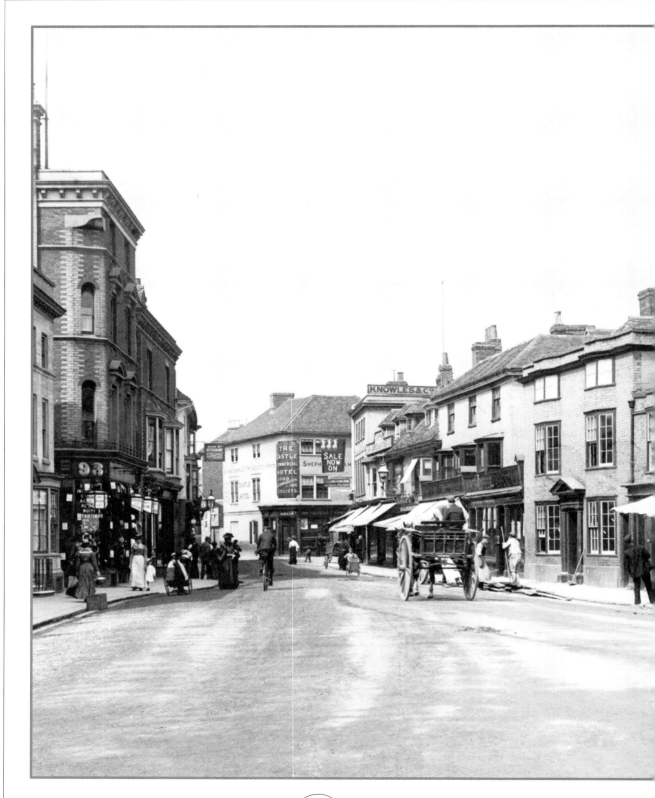

Ashford

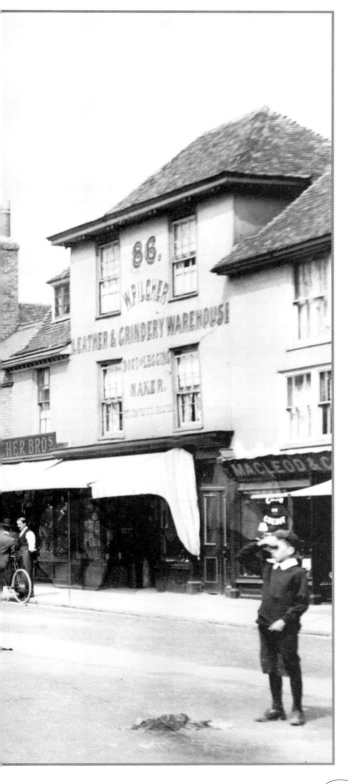

Ashford is a bustling modern town that developed with the railway, but it is also mentioned in Domesday. This old-established market town is dominated by the great pinnacled tower of its fifteenth century church, which is pleasantly situated in a square. Today, offices jostle near to the railway, Ashford International Station and the motorway.

Ashford, High Street 1901 47523
The only traffic here is a horse-drawn cart and a bicycle. By this date, Ashford was also an important railway town with a major carriage works.

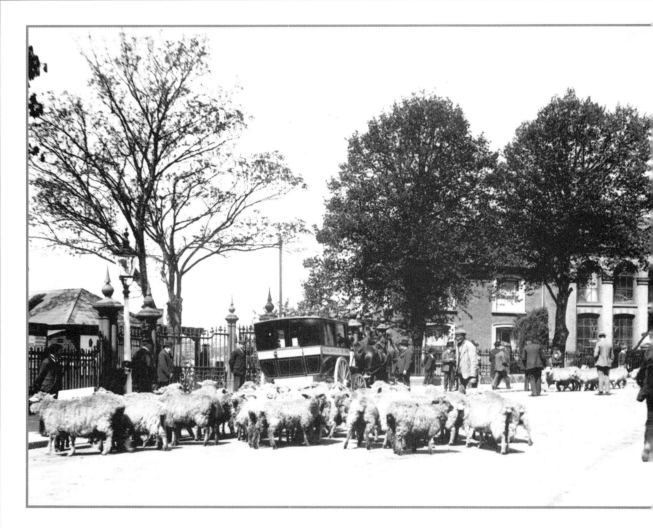

**Ashford, High Street
1906** 53443
This view of the High
Street is taken five years
later, and shows little
change and even less
wheeled traffic. The
double bow-fronted
house has acquired an
awning. The camera
does not seem quite
such a novelty to the
bystanders.

Ashford, Going to Market 1906 53445
A once familiar scene, sheep are being driven to Ashford Market. Ashford has for centuries been an important market town, and scenes such as this, with the sheep in the middle of the street, were once a familiar sight. The cattle market was on the left.

▼ **Ashford, Marsh Street 1903** 50330
A fine view of Marsh Street, with its fine ivy-clad buildings and chapel. Again, only horse-drawn carts can be seen and all seems quiet.

◄ **Ashford, East Mill 1903** 50333
A study of some attractive old cottages at East Mill. A little girl is staring suspiciously at the camera. Note the unmetalled surface of the road. The old timbered cottages are now demolished.

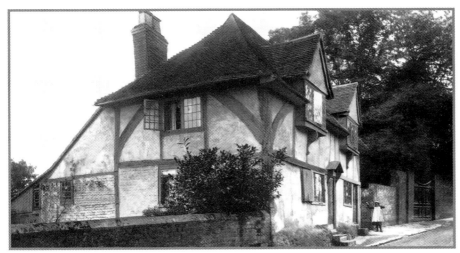

Aylesford

Aylesford is a perfectly sited village by the River Medway and the scene of many battles in ancient times. The medieval bridge is on the site of an ancient ford, once the only crossing between Rochester and Maidstone. The Carmelite friary, rededicated in 1949, is now a place of pilgrimage.

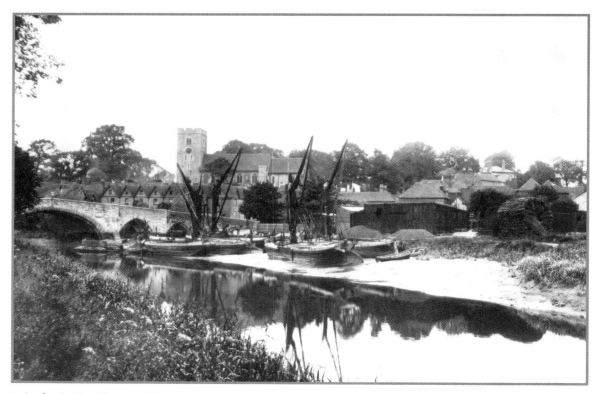

Aylesford, The River Medway 1898 41549
A view from the west bank of the River Medway, looking to the medieval bridge and Aylesford. It is superbly proportioned, with one wide central span and three smaller arches on the approach. Sailing barges are beached on the far shore.

Bearsted

Bearsted is an attractive village that nestles around its ancient village green. Formerly the scene of Civil War skirmishes, it is now famous in cricketing history. The church is Norman, its tower crowned with some curious sculptures of lions. It also has a massive timbered roof.

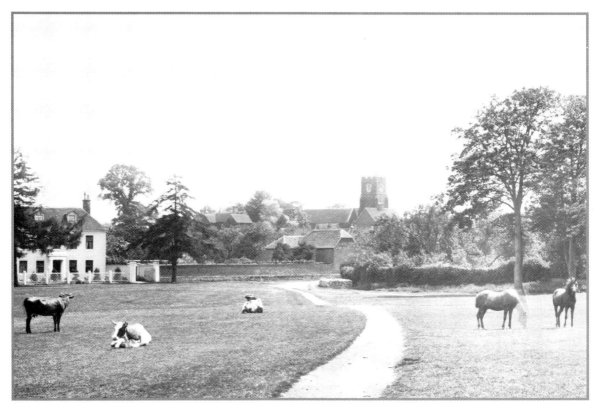

Bearsted, The Green 1898 41565
This view shows the attractive nature of Bearsted's village green, with cattle and horses grazing contentedly on the lush grass. The winding path across the green leads the eye to the distant tower of the Norman church.

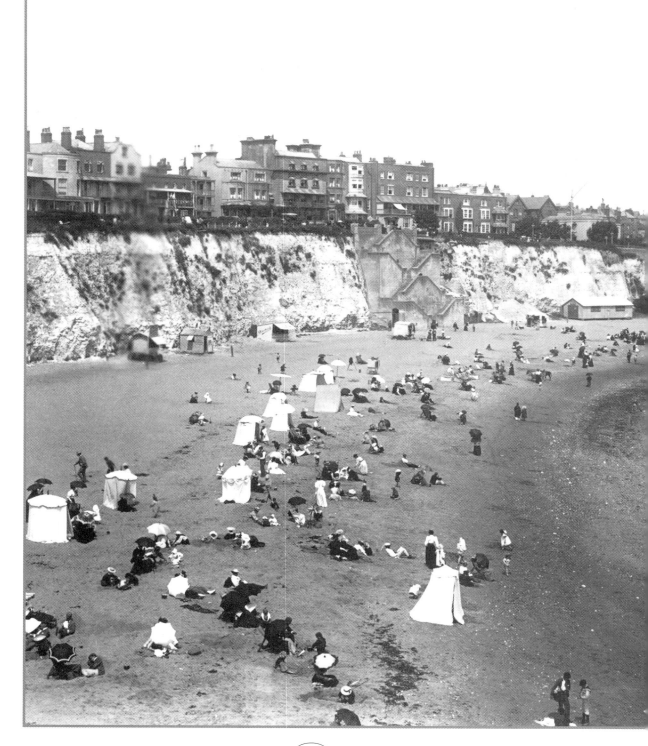

Broadstairs

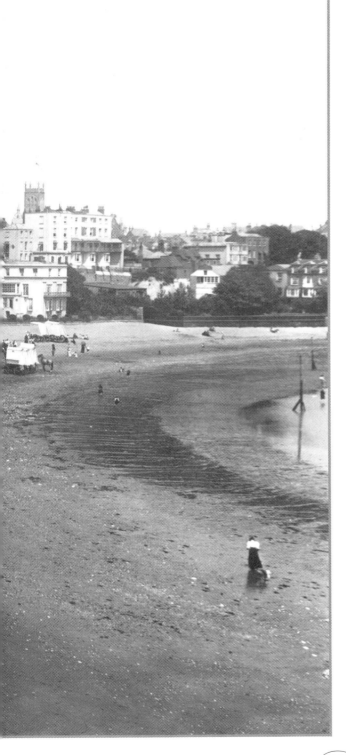

Broadstairs, a well-known resort on the Isle of Thanet between Margate and Ramsgate, retains its village atmosphere. Charles Dickens once lived here, and today there is an annual Dickens festival. It has quaint streets, a promenade, cliffs and a harbour, together with a fine old church. The tower of St Peter's was used as a signalling station in Napoleonic times.

Broadstairs, The Beach 1897 39589
A view of the beach at Broadstairs, taken from the cliff seen in the foreground of picture no. 19708. On the beach are bathing tents and a few bathing machines. In the centre are the stairs down to the sands.

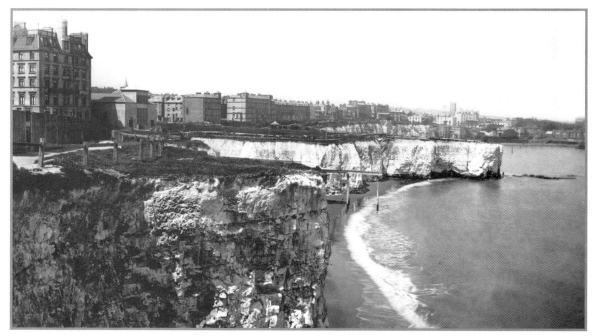

Broadstairs, The Cliffs 1887 19708
A magnificent view of the cliffs from the late Victorian era, the light catching the white chalk. The handsome skyline of Broadstairs, with its fine clifftop establishments and hotels, sweeps round the bay to St Peter's church.

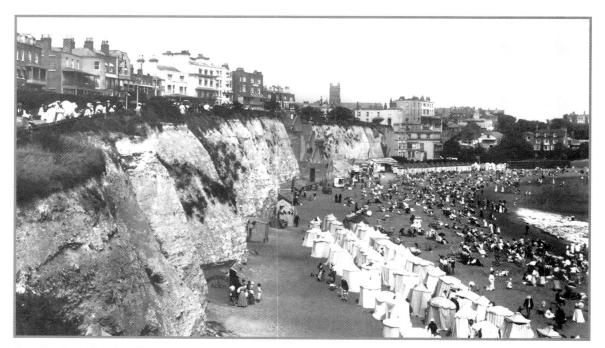

Broadstairs, The Beach 1907 58325
This picture taken ten years later shows a holiday crowd thronging the sandy beach. The bathing tents are obviously busy and have multiplied beneath the cliffs. Meanwhile, promenaders stroll on the clifftop.

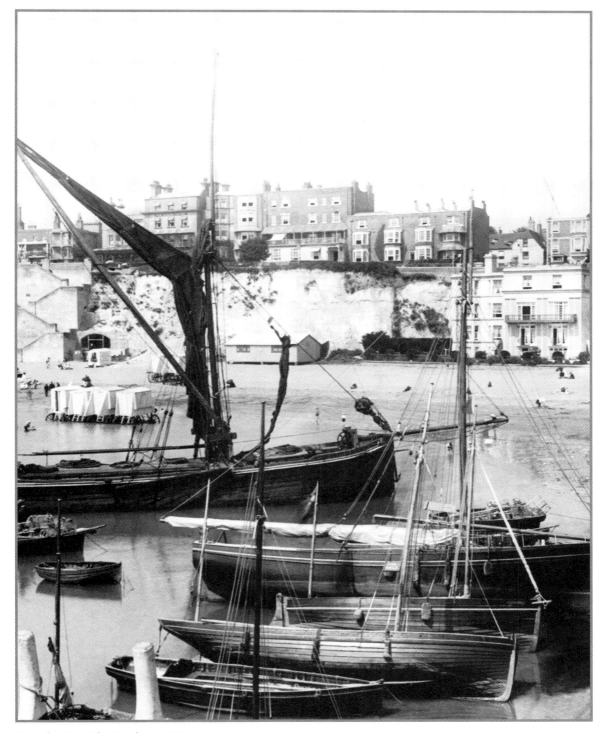

Broadstairs, The Harbour 1897 39592
This splendid view shows part of the fishing fleet and a spritsail sailing barge beached in the shallow waters at low tide. White painted bathing machines are visible behind the barge.

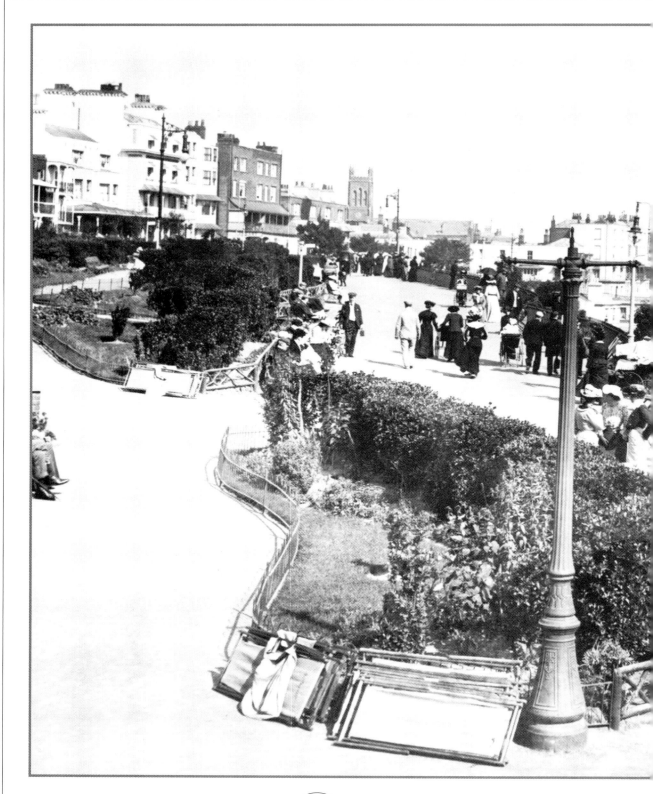

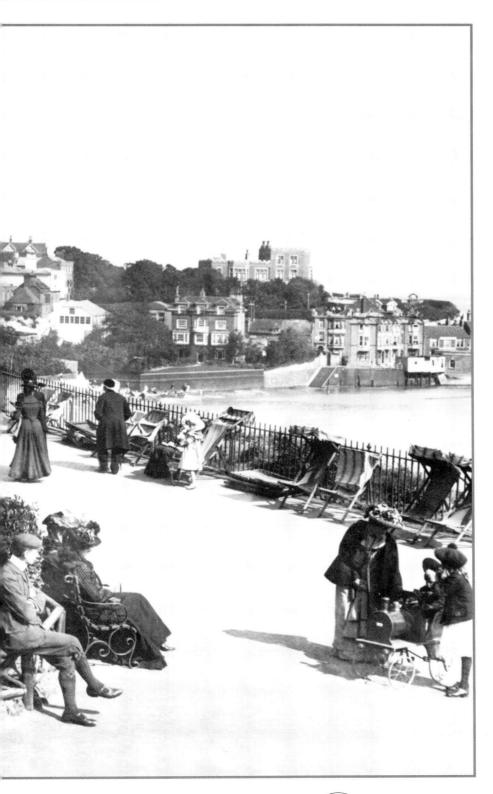

Broadstairs, The Promenade 1902
48842
A turn of the century view of the promenade, showing St Peter's Church, Bleak House and the harbour. Note the deckchairs stacked up against the railings ready for use, and the child sitting on a toy pedal-train.

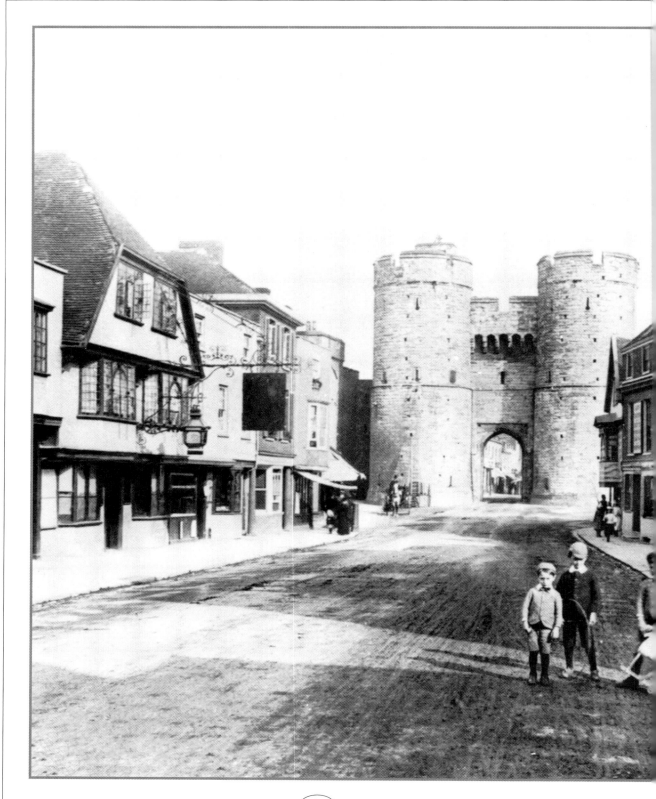

Canterbury

This historic city is dominated by its famous cathedral, and has since Saxon days been the spiritual capital of England. The cathedral was rebuilt in the 12th century, and began to assume the form we see it in today. It was here that Thomas a Becket was murdered in 1170, and the city has been a place of pilgrimage ever since. The crypt is the finest of its type in the world.

Canterbury, The West Gate 1890 25695
A view of the West Gate of the city. Its massive proportions emphasise its historic role of guarding the town. Three boys pose for the camera.

▼ **Canterbury, The Cathedral 1888** 21350
A fine study of the cathedral with the huge west front dominating the scene. Perhaps the most famous symbol of the Anglican church, it is a dominant landmark for many miles around.

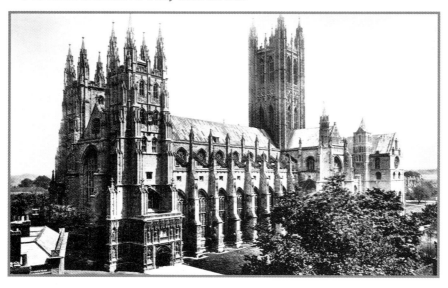

▼ **Canterbury, The Cathedral Crypt 1888** 21396
The crypt at Canterbury dates from Norman times and is one of the cathedral's many treasures. This excellent study was taken in 1888 and is a rare and wonderful picture; the awesome majesty of the subterranean setting symbolises the ancient mysteries of the Christian tradition.

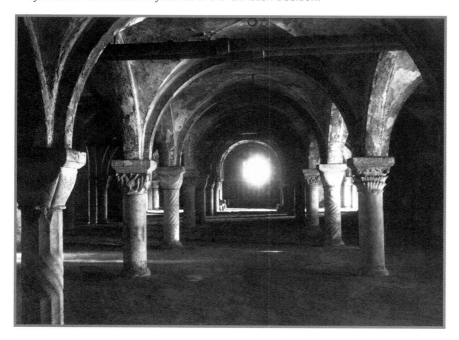

▲ **Canterbury, The West Gate 1921** 70330
The Frith photographer returned just over thirty years later to take a further picture of the West Gate. A car and motorcycle are now in evidence, but little else has changed.

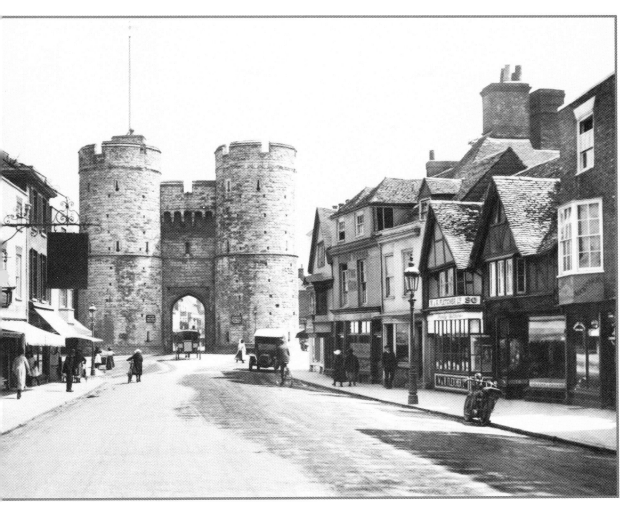

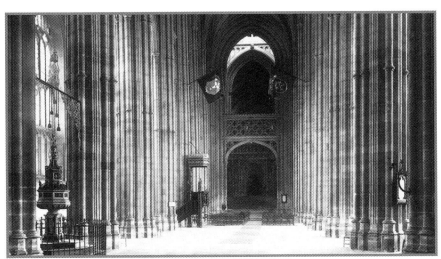

◀ **Canterbury, The Cathedral Nave 1898**
40840
The nave took 28 years to build, and was completed in 1405. The huge proportions and the nobility of the architecture are still breathtaking, almost 600 years later.

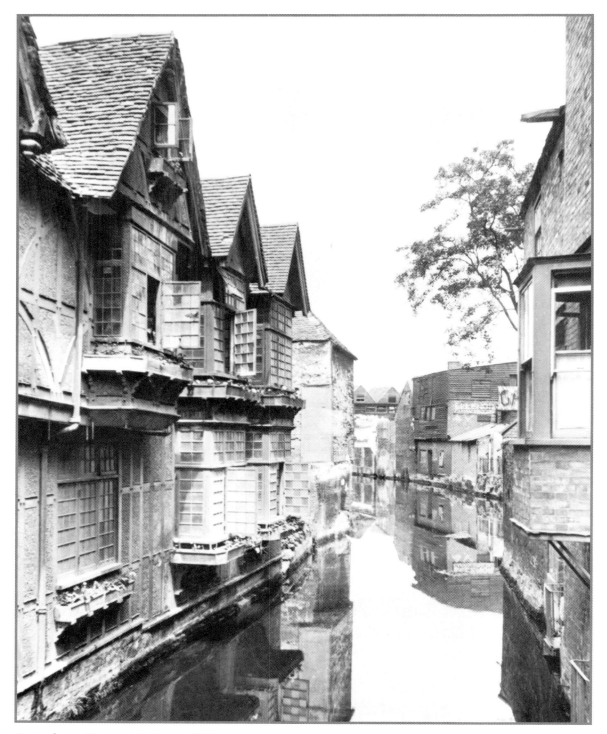

Canterbury, Weavers' Cottages 1921 70331a
In these back street cottages on the river the Huguenot weavers once worked on the Kentish cloth. This scene is just off the High Street - the river is the Stour.

Chatham

Chatham is famous in the annals of English seafaring history. It was first developed as a safe anchorage in Tudor days, and later a large dockyard and arsenal were established. In recent years it has become, with Rochester, a major tourist attraction.

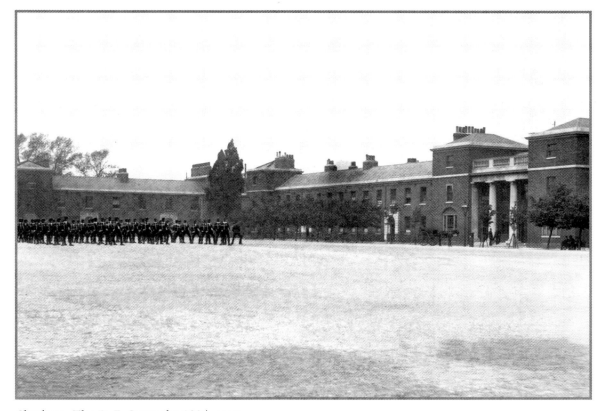

Chatham, The R. E. Barracks 1894 34041
This view shows the Royal Engineers on parade at their barracks on the hilltop, and emphasises Chatham's long associations with the military. Note the spectators sitting under the trees on the right.

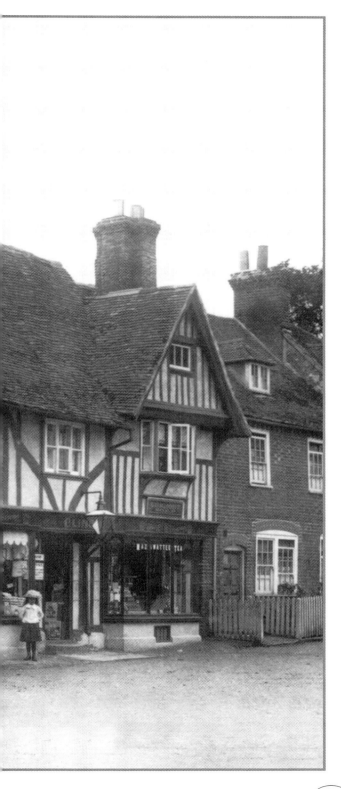

Chilham

Chilham is a delightful village set high on the downs. Its pretty houses grouped around a square by the castle gates lend it a timeless air. The ancient castle was replaced in the seventeenth century by the present mansion, which has spacious gardens set out by Tradescant. The 15th-century church is rich in monuments.

Left: **Chilham, The Post Office 1903** 50344
An early 20th-century view of that bastion of English life, the Post Office. Here is a lovely half-timbered building in this picturesque little village on the Canterbury road. A little girl stands proudly in front, whilst next door baskets are for sale.

Below: **Chilham, The Castle 1903** 50346
A view across the park to Chilham Castle, built by the Normans on an ancient site. Only the keep now remains, and can be seen on the left of this picture.

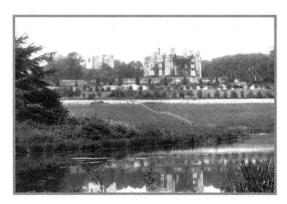

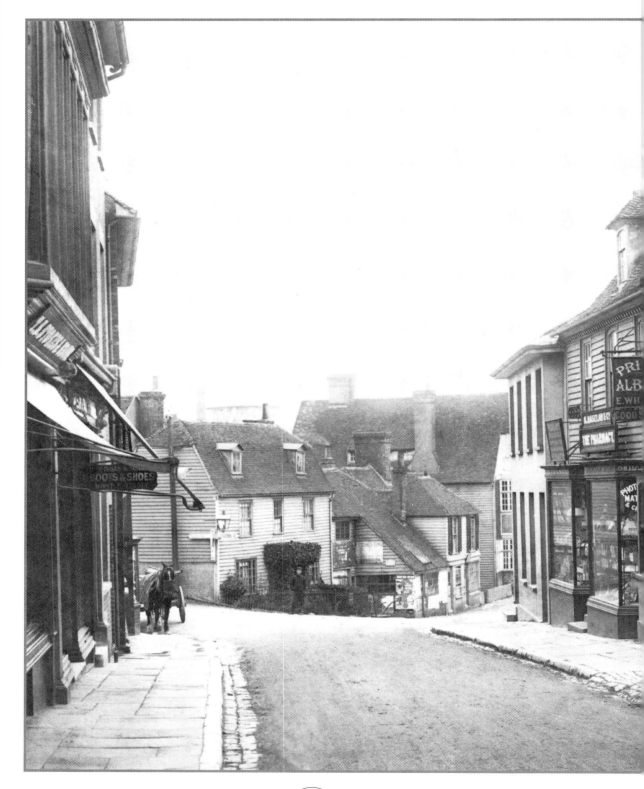

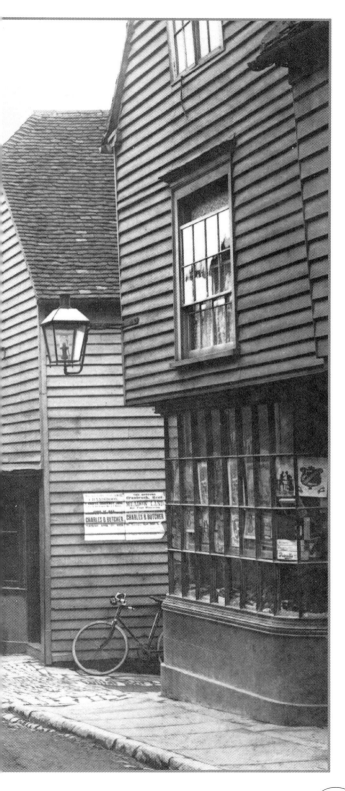

Cranbrook

This perfect little town, the capital of the Kentish Weald, was formerly a centre of cloth weaving. Its typical Kentish architecture of weatherboarded houses is complemented by the Union Mill, the largest working windmill in England. The view from Stone Street is perhaps one of the most famous of all Kentish scenes. The ancient church has many treasures, and there are many other interesting buildings.

Cranbrook, Stone Street 1903 51010
This is the classic view of Cranbrook, with Kentish weatherboarding much in evidence. The white painted Union Mill merges into the grey of the skies.

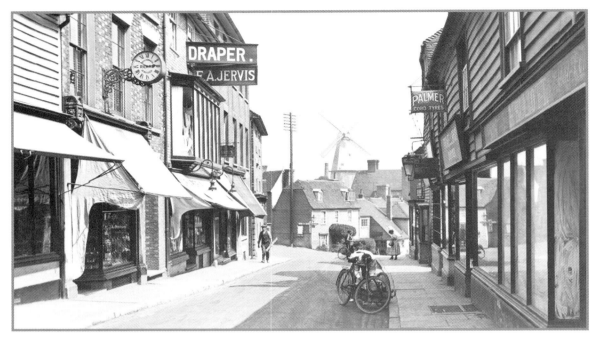

Cranbrook, Stone Street 1925 77023
A fine study of Stone Street, this time taken on a sunny day. In this view, the famous Union Mill stands proudly on the hill, whilst bikes are parked along the kerb.

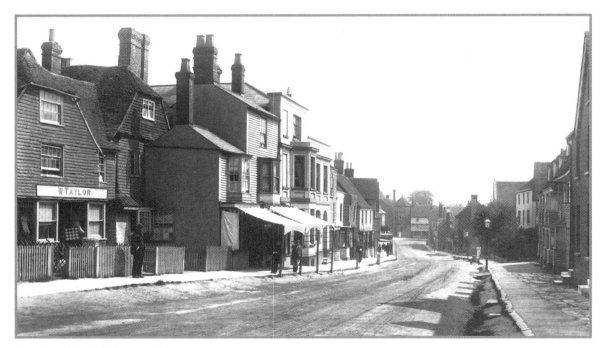

Cranbrook, High Street 1901 46430
Note the broad width of the street where the market used to be held, and the pleasing variety of architecture and raised pavements.

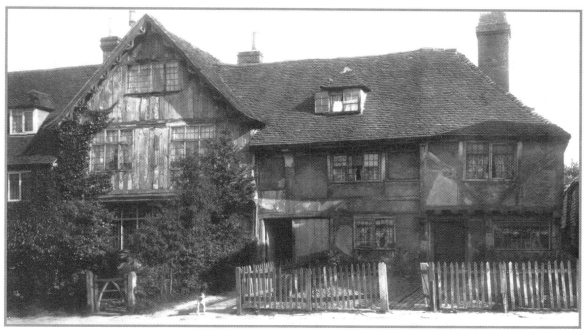

Cranbrook, The Studio 1901 46432
Situated on the High Street is The Studio, a Wealden Hall House, with a later gable on the left-hand side. This picture was taken before restoration. Note that the building is divided into several houses.

Cranbrook, The Providence Chapel 1908 60297
The Providence Chapel was built in 1828, and is one of Cranbrook's most memorable buildings. It has a seven-sided front made of timber, cleverly grooved to look like stone.

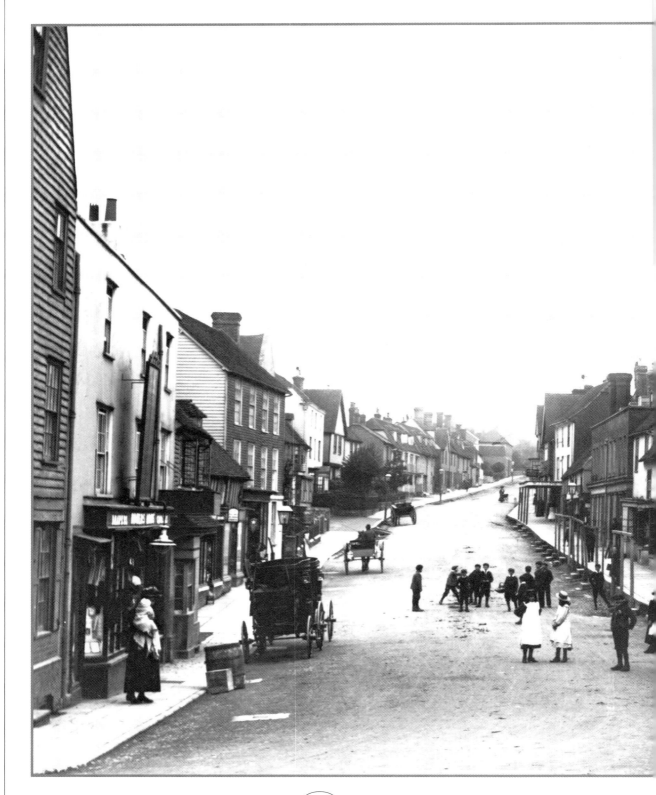

Cranbrook, High Street 1903 51009
This view is taken from the junction with Stone Street, looking up from where view number 46430 was taken. There is much more activity, with horse-drawn carriages and children playing in the wide road.

Dartford

Although Dartford is now an industrial town, it has a long history that stretches back to Roman times and earlier, and is an important crossing place over the River Darent. The church has Norman foundations, and there was once a priory here. In later years Dartford became a shipbuilding centre. Famous for the Dartford Tunnel, it is overshadowed by the new Queen Elizabeth Bridge, that carries the M25 over the River Thames.

Dartford, Holy Trinity Church 1902 49020
A fine view of Dartford's Holy Trinity Church, showing the Norman tower. Note the baby in the pram by the church door, and bystanders posing for the camera.

Dartford, The Crown and Anchor c1955 D3069
This view of the Crown & Anchor shows Dartford's narrow streets. The Crown is paying homage to the town's celebrated rebel, Wat Tyler, who was born here in the 14th century. His name has now been appropriated by the pub.

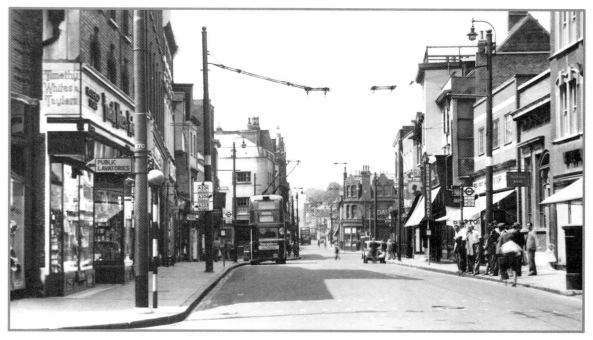

Dartford, High Street c1955 D3031
The lack of traffic strikes us today as remarkable, and the trolleybus emphasises that this picture was taken in an era now long gone.

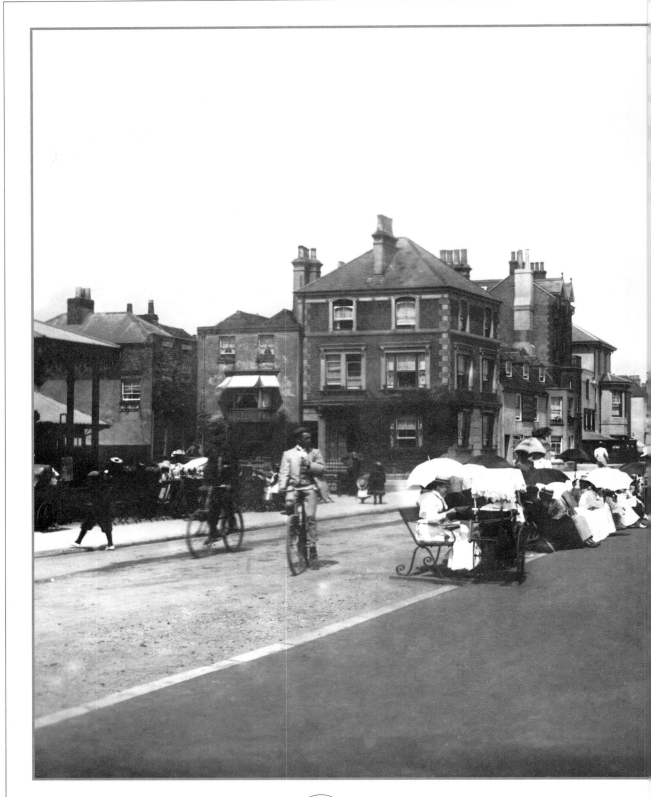

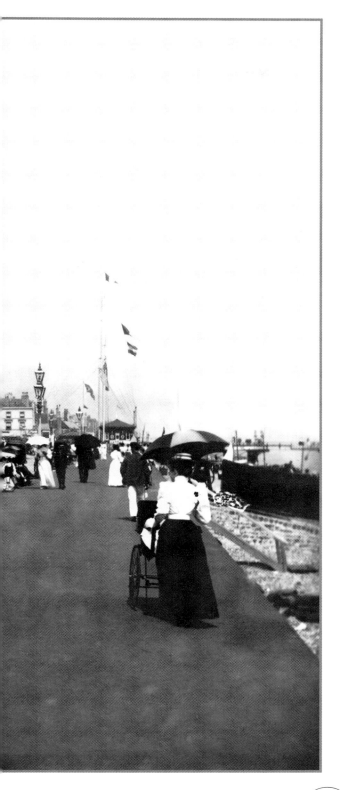

Deal

Deal is a delightful small resort which became very popular Victorian times. Yet it has a long history with a number of attractive 18th- and 19th-century houses tucked away in the lanes of the Old Town. However, Deal is best known today for its attractive seafront, with its promenade and pier. The castle was built in Tudor times as part of the coastal fortifications.

Deal, The Esplanade 1899 44206
A windy day on the Esplanade that epitomises the closing days of the Victorian era at a refined seaside resort. Parasols, prams and bicycles are much in evidence.

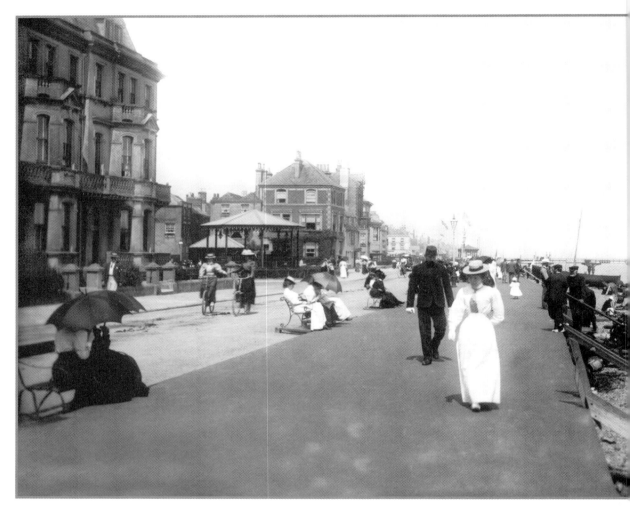

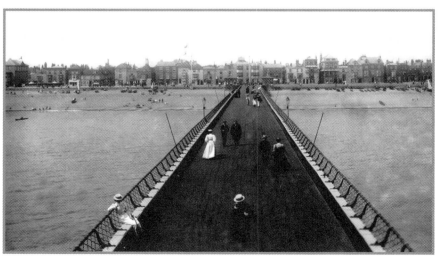

◀ **Deal, From the Pier 1899** 44203
Deal is an elegant town, and nowhere is this clearer than in this view, taken from the Pier pavilion looking back to the town. The grace of the pier is matched by the best dresses and suits of the promenaders. The pier has now been replaced with one built in the 1950s.

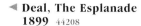

Deal, The Esplanade 1899 44208
This view is taken from slightly further along the Esplanade than photograph No 44206. It shows clearly the steps down onto the shingle beach, together with the boats drawn up in time-honoured fashion. Part of the pier can be seen.

Deal, The Bandstand and Pier 1906 56911
This view shows the bandstand and the graceful pier and pavilion. The beach is now full of deckchairs, and a band is busy entertaining the summer visitors.

Deal, Beach Street 1924 76068
This interesting view shows the fishing boats drawn up onto the shingle beach; in the foreground the capstans can be seen that used to haul the boats up the beach.

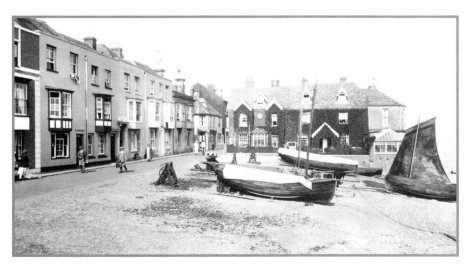

Deal, The Old Town and the Parish Church 1918 68501
This view shows the old village of Deal, now known as Upper Deal, as it looked in 1918. The parish church of St Leonard's, basically medieval but much rebuilt in 1684 and sporting a cupola, is a landmark for shipping.

Dover

Dover is one of England's most important seaports, and is still very busy today. The castle dates from Norman and medieval times, but was remodelled greatly in the Napoleonic era. The site was first developed by the Romans, and the Roman lighthouse stands within the modern castle walls. The old harbour lies under the modern town, which was hit by bombing in the Second World War.

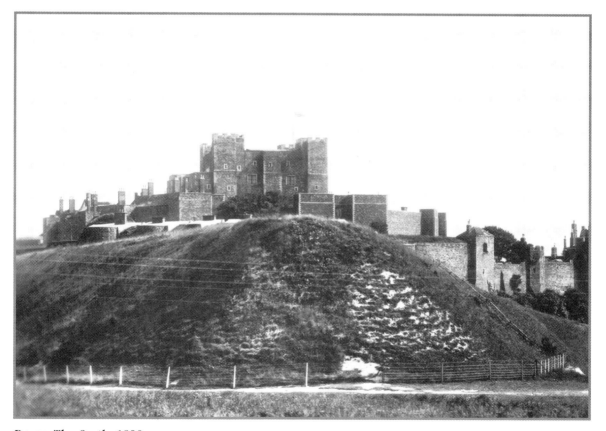

Dover, The Castle 1890 25703
This is a rather menacing view of the famous castle. It is a magnificent building, which dominates the town and the harbour. It was always a vital fortification, and was still used by the Army up until the late 1950s.

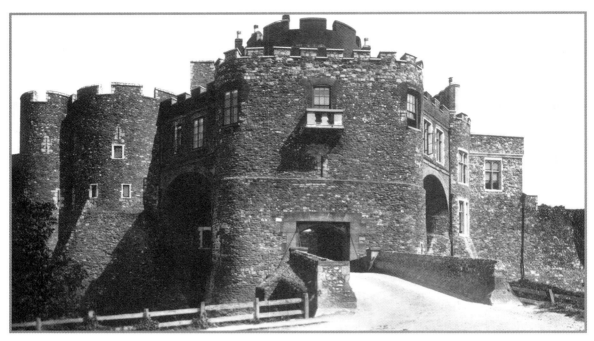

Dover, The Castle 1890 25707
The enormous proportions of the castle can be seen in this view of one of the three entrances to the castle, Constable's Tower. Today, the castle is in the care of English Heritage.

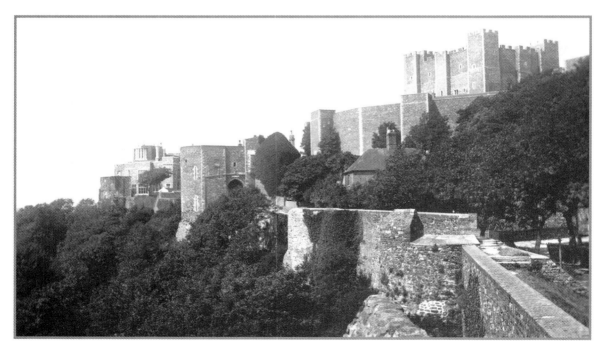

Dover, The Castle 1890 25705
This fine study of the castle shows the vast curtain wall and the medieval Castle Keep. It was built by Henry II and is the main residential building.

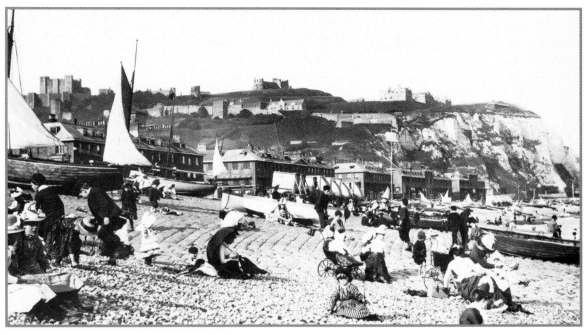

Dover, The Beach 1890 25699
This picture shifts the scene down to the beach; we are looking east to the castle and the chalk cliffs. Pleasure boats are in evidence, and holidaymakers are clearly enjoying a day in the Victorian sunshine.

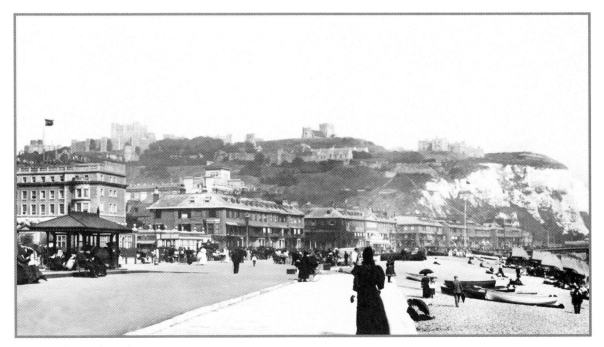

Dover, The Esplanade 1899 44794
This fine view of Dover's sweeping Esplanade shows bathing machines pulled down near the water. Dominating the scene is the castle, with the Saxon St Mary's Church, together with the Roman lighthouse, in the centre.

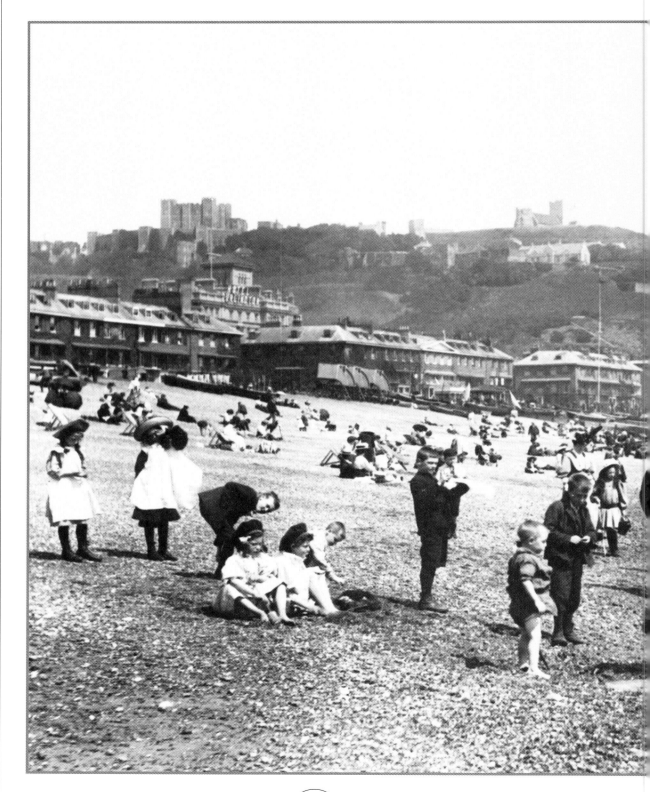

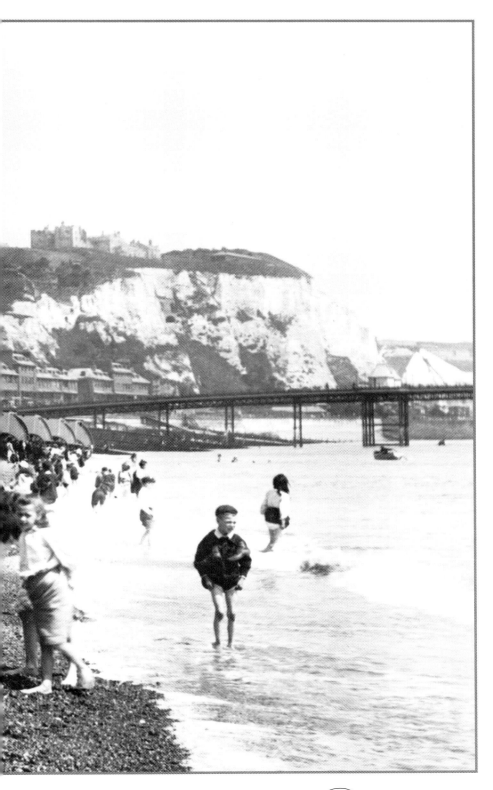

**Dover, The Beach
1908** 60402
Here we see a delightful
grouping of children
enjoying a paddle in the
sea. In this timeless
scene, the guardian
white cliffs can be seen
in the background.

Faversham

There has been a settlement at Faversham since Roman times, and this little town at the head of a tidal creek still has a commercial quay. Although it is at the centre of an industrial area notable for brewing, the town retains an ancient peace. It was granted a charter in Saxon times.

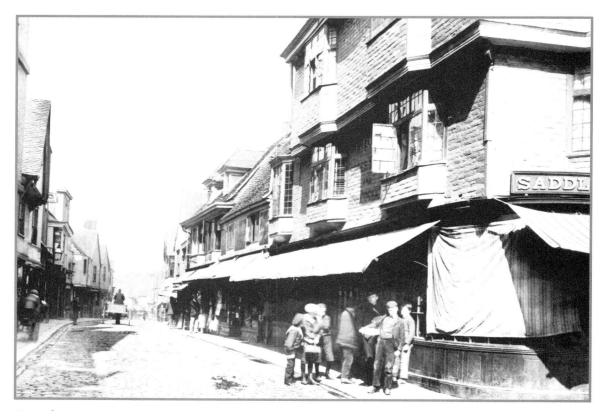

Faversham, West Street 1892 31470
West Street is Faversham's most famous street. It is lined with many historic buildings, and connects the historic town with Faversham Creek. When this picture was taken, the street was cobbled.

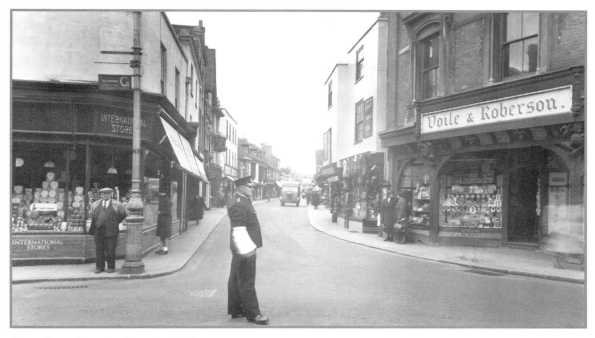

Faversham, Preston Street c1955 F13019
Preston Street links the station with the market town centre. A policeman stands on point duty; once again, one is struck by the lack of heavy traffic.

Faversham, The Recreation Ground 1892 31474
A group of children pose for the photographer. They have managed, with one notable exception in the middle, to keep still for the length of time exposures needed in those days.

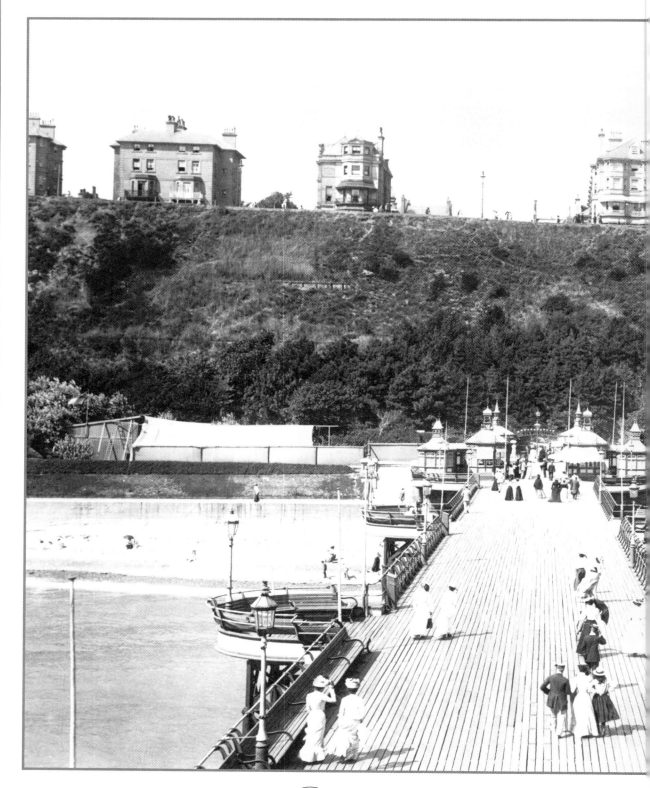

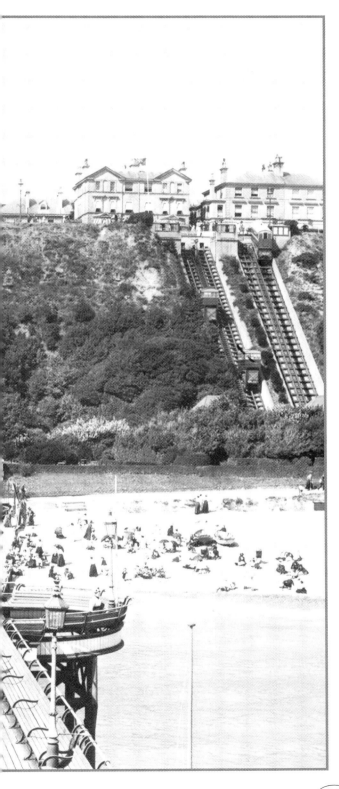

Folkestone

Folkestone has been a channel port since Saxon times, and France is visible from here on clear days. The Old Town is based around the steep narrow streets of the fishing harbour. The extensive seaside resort was developed in Victorian days, after the arrival of the railway. The docks are still busy, but the pier has now gone.

Folkestone, The Leas from the Pier 1901 48054
This view shows the Leas, and was taken from the pier. This promenade is about one and a half miles long, with gardens and a pavilion. To the right can be seen the water-balanced lift, which still saves holidaymakers the bother of climbing to the top.

▼ **Folkestone, The Pier 1892** 29939
A fine view of the 680 ft long Victoria Pier. The handsome pavilion could accommodate 800 people, and in the summer concerts were given daily.

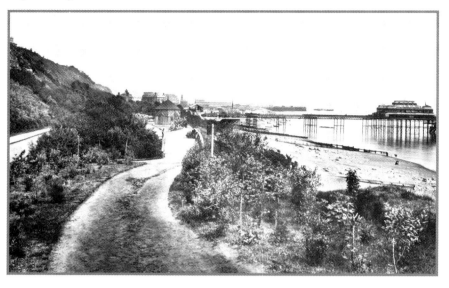

▼ **Folkestone, The Harbour 1912** 65003
Setting out on a fishing trip, one of Folkestone's fleet leaves the inner harbour. Folkestone is now known as a cross-channel port which developed in early Victorian days, and a steeply-graded branch railway line was built from the main line to the harbour.

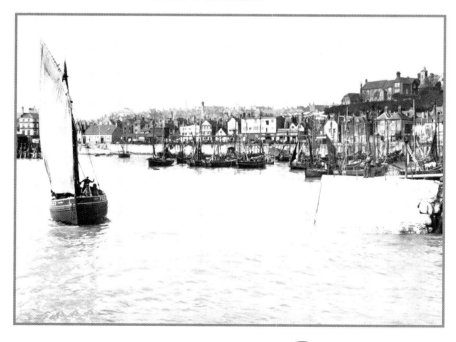

▲ **Folkestone, The Beach 1901** 48056
Rowing boats are drawn up, and mothers and children are enjoying a paddle in the sea. The harbour is in the background.

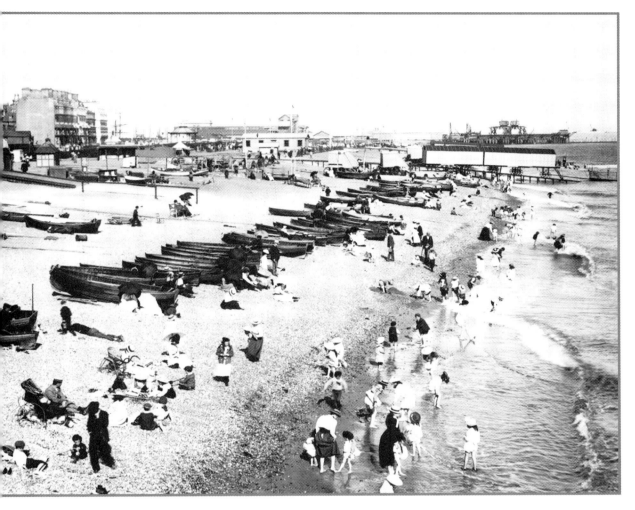

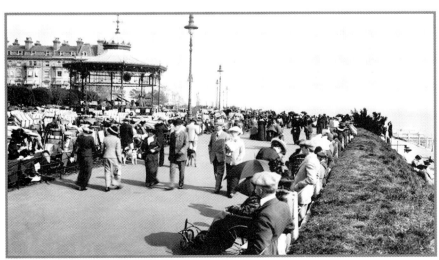

◀ **Folkestone, The Bandstand and Promenade 1912** 64993 This happy summer scene of Folkestone promenaders was taken from near the bandstand. Folkestone was proud of its bandstands. It had three at one time, and only bands of the highest standing were engaged.

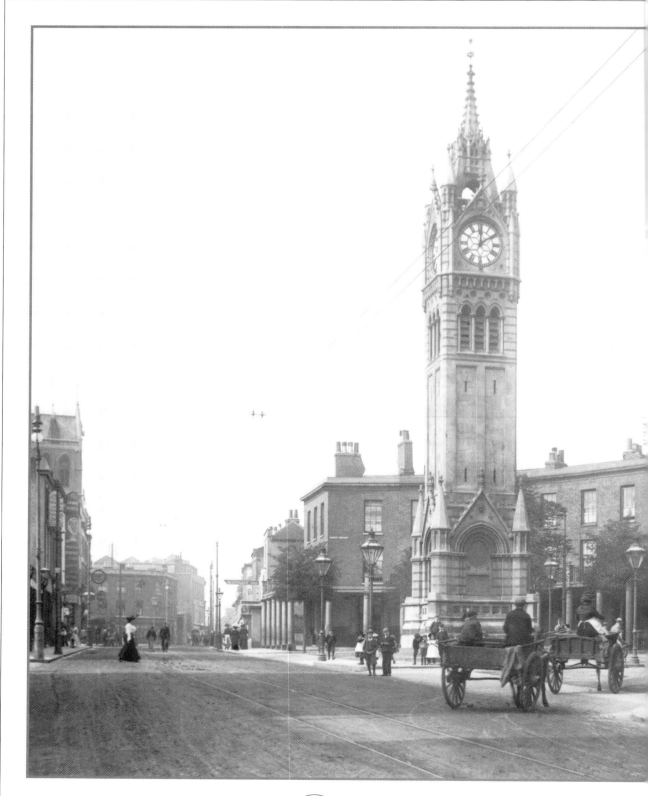

Gravesend

Gravesend is a busy industrial town on the river Thames; here the river narrows to become a London river, and coastal pilots hand over to the river men. It has a long history of seafaring, and fleets were assembled here in Tudor times. Its grimy facade hides buildings and churches of much interest. The view from nearby Windmill Hill is spectacular.

Gravesend, The Clock Tower 1902 49026
The handsome clock tower was built in 1887, and was only 15 years old when this photograph was taken. The overhead wires for the trams clutter the scene.

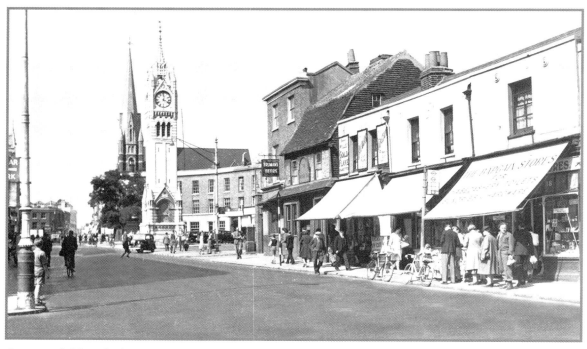

Gravesend, The Clock Tower c1950 G47009
Behind the clock tower the Methodist church has appeared; it was built in 1906. The tramlines have disappeared.

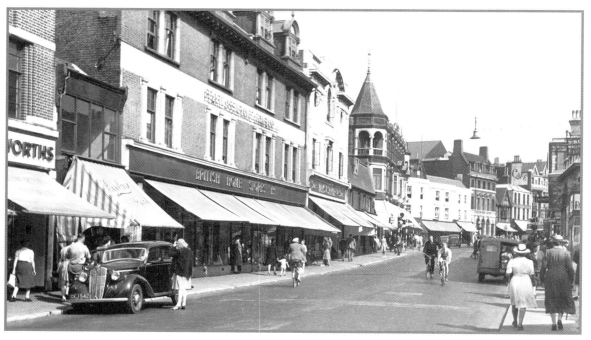

Gravesend, New Road c1950 G47003
New Road is one of the main shopping streets of the town. The roads seem empty by today's standards. In the foreground is British Home Stores, and Woolworths is on the extreme left.

Gravesend, High Street c1950 G47010
A final view of Gravesend, this time showing the narrow High Street. No cars can be seen. The sign in the top middle of the picture shows Timothy Whites, which was bought out by Boots and closed down in the late 1970s.

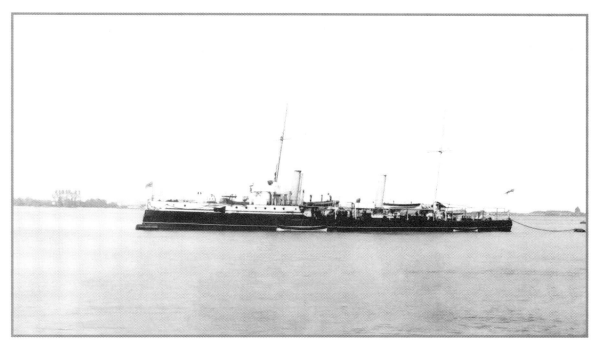

Gravesend, HMS 'Gleaner' 1902 49043
The destroyer HMS 'Gleaner' is anchored out in the London river where it becomes the Thames estuary. Gravesend was the place where those who had died at sea would be offloaded for burial in the town cemetery.

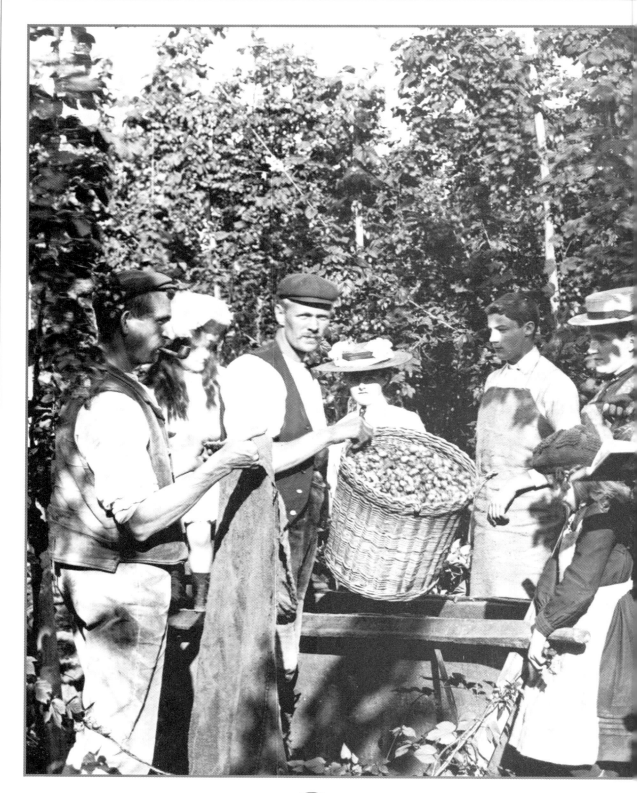

Goudhurst

This beautiful village is set up on a hilltop, surrounded by orchards and hopfields. The High Street has attractive tile-hung and weatherboarded cottages tumbling down the hill. From the church it is possible to see Rochester and Hastings. The 14th-century church has many monuments to the Culpepers. Near the village is Twissenden Manor, a fine Jacobean house.

Goudhurst, Hop Picking 1904 52571D
Kent is synonymous with the growing of hops. This labour-intensive work was done by poor London families coming down for their annual paid holiday. Here, the hops are being measured before being loaded into a poke - the tallyman is second on the right.

Goudhurst, The Parish Church 1901 46379
St Marys, Goudhurst's church, was founded in the 14th century, with its tower built in 1640. It crowns the hill, and
has many monuments to the Culpeper family.

Goudhurst, The Village 1901 46377
The village of Goudhurst has always ranked as one of the most graceful of the Kentish Weald. This view shows the hilly nature of the place, perched over 400 ft up.

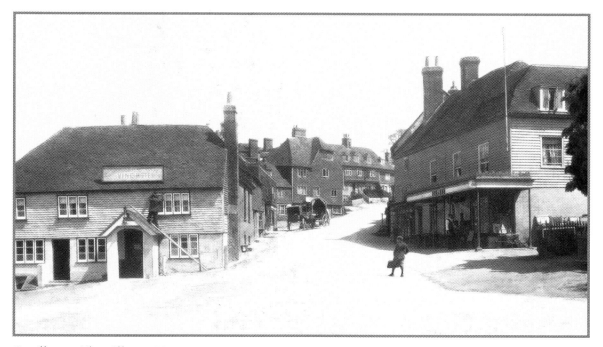

Goudhurst, The Village 1901 46376
This fine study of Goudhurst looks up the High Street. The Vine Hotel stands on the left, whilst halfway up the hill is a horse-drawn wagon.

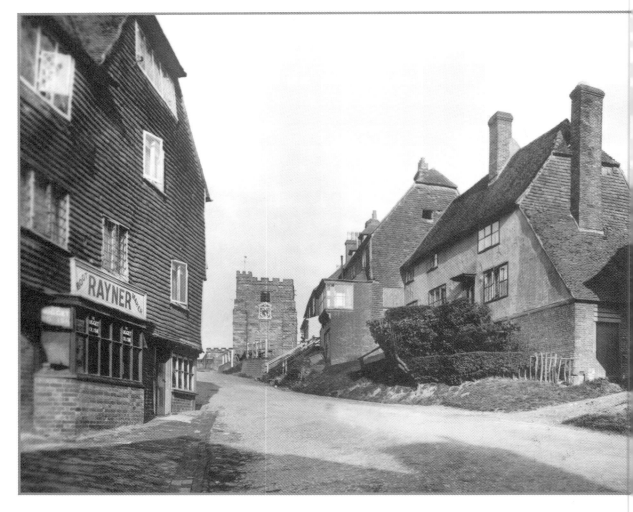

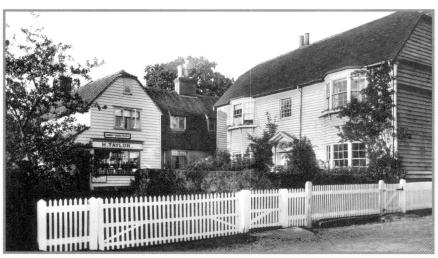

◀ **Goudhurst,
Cranbrook Road 1904**
52546
A further view of
Goudhurst, this time
showing the Kentish
weatherboarded houses
and shops on the
Cranbrook Road on a
summer's day. Note the
white-painted fence -
another Kentish
speciality.

◀ **Goudhurst, The Village 1904** 52537
A picture postcard view of Goudhurst, looking up the hill to the church peeping out at the top. This view is little changed today. Note the typically Kentish hipped roofs and hung tiles.

▼ **Goudhurst, The Plain 1904** 52538
This view shows the Plain. On the right, beside the village pond, a horse-drawn wagon and a group of people wait in the shade.

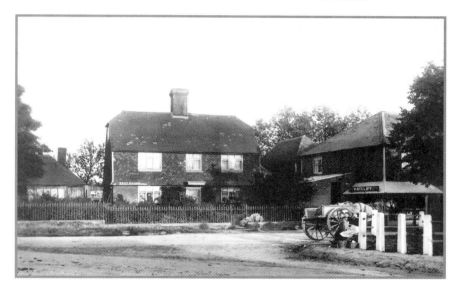

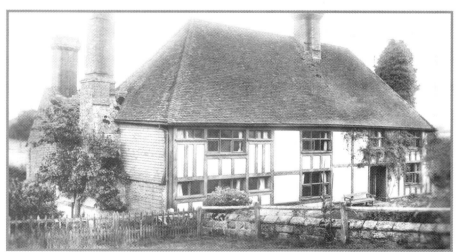

◀ **Goudhurst, Twissenden Manor 1904** 52562
A few miles to the south of Goudhurst is Twissenden Manor, now a youth hostel. This half-timbered Wealden Hall House has a late 16th-century sandstone facade at the back.

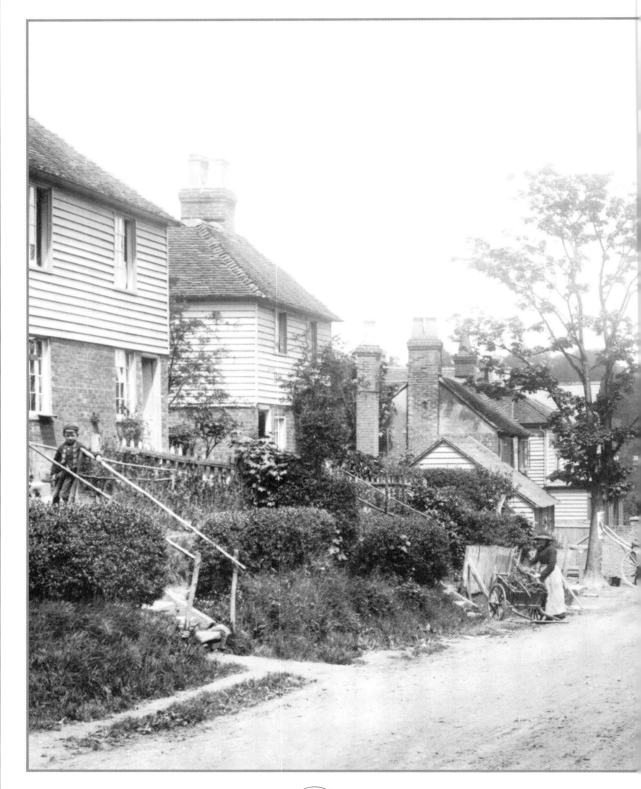

Hawkhurst

This scattered village is situated in the heart of the Weald. It is an old centre with a 15th-century church, which has many fine treasures. Its weatherboarded cottages surround its tree lined green. There is also an elegant Regency parade of shops, the Colonnade, situated at the crossroads.

Left: **Hawkhurst, The Village and Moor Hill 1902** 48255
This view looks towards the spire of the church across the valley. It shows a cart ascending Moor Hill, past typically Kentish half-weatherboarded cottages.

Below: **Hawkhurst, The Queen's Hotel 1902** 48248
This fine study of the Queen's Hotel was possibly taken as a picture postcard or promotional picture. This old coaching inn was built to serve travellers on the Flimwell to Rye turnpike road, which was set up in 1762; it is now the A268.

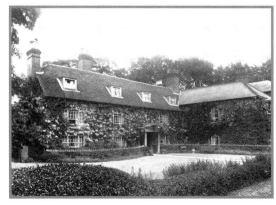

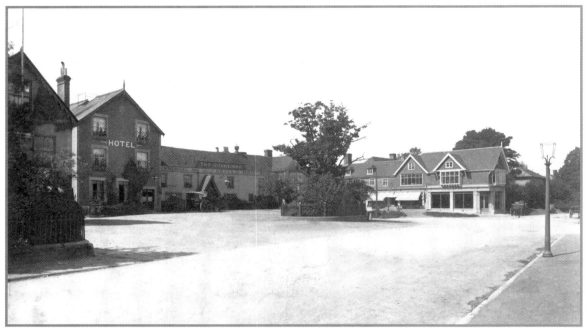

Hawkhurst, Highgate 1904 52118
Highgate is the modern Hawkhurst, which has grown up along the A268. This view shows the square; there are a few carts to be seen, but otherwise it is a quiet afternoon scene.

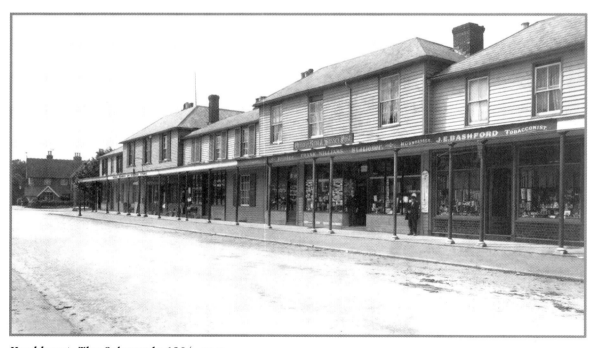

Hawkhurst, The Colonnade 1904 52119
The photographer moved back down the road and caught the colonnade of shops, one of Hawkhurst's best known features; this is an early 19th-century shopping arcade with weatherboarded houses and cast-iron columns.

Herne Bay

Herne Bay is a popular resort on the north Kent Coast,
founded in the 1830s, and popular ever since. The town
has a seven-mile beach, stretching from Warden Point to
Reculver. The seafront is dominated by a Victorian clock
tower. The pier was burned down in 1970, and the spot is
now marked by a leisure centre.

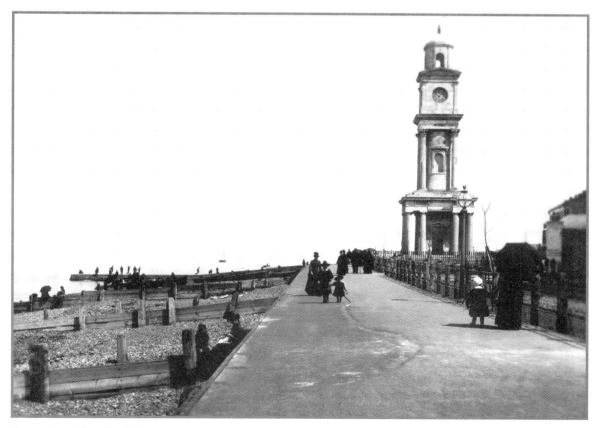

Herne Bay, The Clock Tower 1889 22313
The 85 ft high clock tower dominates this view of the parade. The clock tower was built in 1837, and was the
tallest in the world at the time.

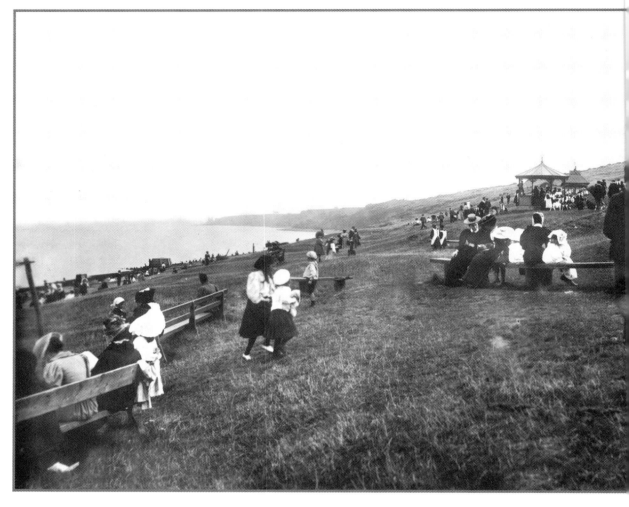

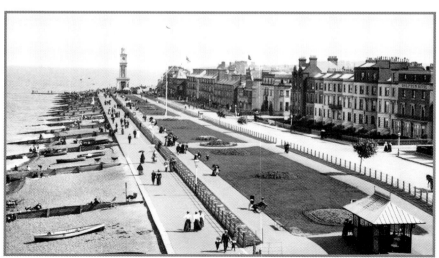

◄ **Herne Bay, The Parade 1894** 40150
This tranquil view shows promenaders on the parade. The picture was taken from the pier, which was built in 1873 to replace the earlier and more ambitious pier designed by Telford. Herne Bay was always a popular family resort.

Herne Bay, East Cliff 1897 40162
East Cliff is a popular spot of rough grassland where the downs meet the sea. The beach could be reached by a series of steps known as 'The Hundred Steps'.

Herne Bay, East Cliff 1927 80119
It is a generation later, and fashions have changed among holiday makers on East Cliff, as this picture shows, although nearly everyone is still wearing a hat. Deckchairs are much in evidence.

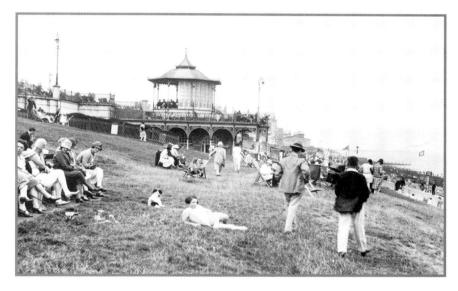

Herne Bay, The Bandstand 1927 80116
Here we see the central bandstand on the seaward side of the parade. Here the audience are assembling for what looks like a Sunday Concert. An open-topped tourer and motor-cycles are parked by the entrance railings.

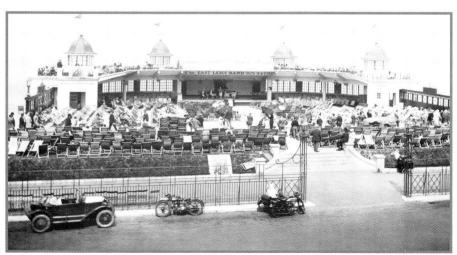

Hever

A castle, a church, an inn and houses huddled closely together near the Sussex border. The church is 14th-century, with a charming shingled spire. Today, Hever is best known for the moated Hever Castle, restored at the beginning of the 20th century. The gardens are magnificent, and the house contains a marvellous collection of paintings and furniture.

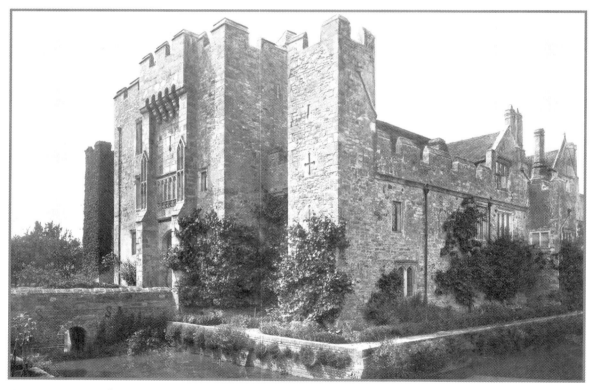

Hever, Hever Castle 1891 29396
This photograph was taken twelve years before the start of the castle's restoration by Lord Astor; at this time, its associations were solely with the romantic attachment of Henry VIII and Anne Boleyn. The square sandstone house dates from 1384.

Hever, The Bower 1906 53557

This is a charming piece of old Kent. Note the typical Kentish architecture - hung tiles and a hipped roof - and the big conservatory and the round oast house to the right.

Hever, The Village 1906 53550

Here we see Hever prior to Lord Astor's creation of a Tudor-style village adjacent to the castle. A horse-drawn wagon comes down the lane, and to the left is the spire of St Peter's Church.

Hythe

This old town, one of the Cinque Ports, is now very much a seaside resort close to Romney Marsh. The Royal Military Canal divides the resort from the old town, with its narrow twisting streets leading up to the medieval church. Today, it is the terminus of the Romney, Hythe and Dymchurch Railway.

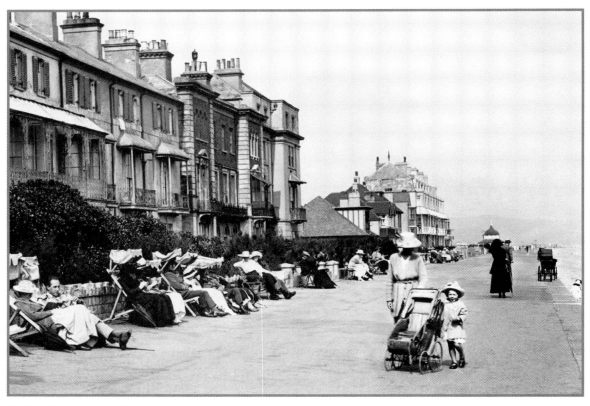

Hythe, The Parade 1918 68149
A wonderful study of canopied deckchairs on Hythe Parade. It is curious to realise that this gentle holiday scene was probably taken during the closing months of the First World War.

Ightam

Ightham is a lovely old village of half-timbered cottages and houses, with a 14th-century church. Nearby is Ightam Mote, a famous secluded manor house, which can trace its history back to medieval times. Among its many splendours, Ightham Mote has a 15th-century great hall, an old chapel and a crypt.

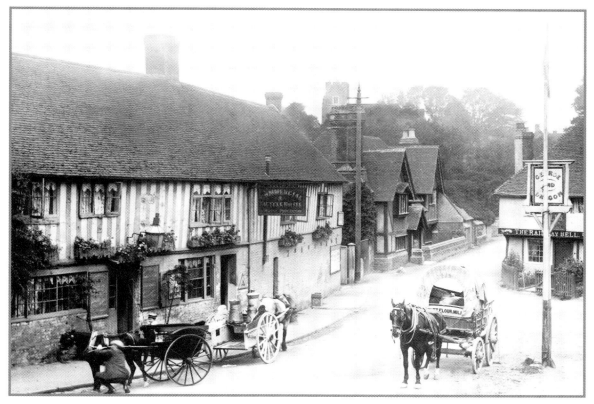

Ightham, The Square 1901 47623
Ightham Square is pictured early in the morning: delivery men are making their rounds - note the churns on the milk cart in the centre. The George and Dragon Inn, on the left, was built in 1515.

Kingsdown

Kingsdown is situated to the south of Deal. Modern housing on the cliffs vies with the older fishing village beneath the cliffs by the beach. It is reputed that Julius Caesar landed here on the steep shingle beach in 55 BC. The church, built in florid Gothic, is Victorian.

Kingsdown, The Village 1906 56926
Here we see the old fishing village on a summer's day. The post office is on the extreme right of the photograph, while the church roof is visible to the right of centre. The wooded cliff behind is now largely developed.

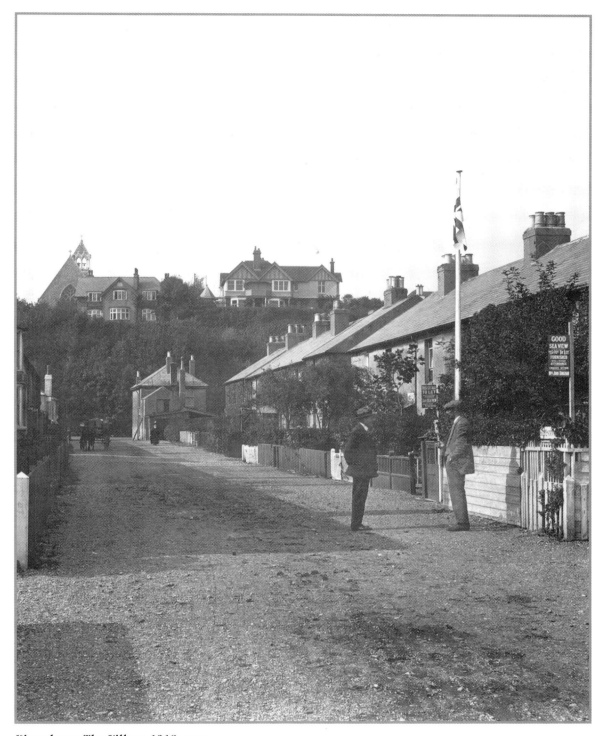

Kingsdown, The Village 1918 68506

A conversation piece in Kingsdown village. With the First World War still rumbling on the Union flag has been hoisted on its white flagpole, but it hardly stirs in the summer breeze.

Littlebourne

This is a pleasant village at a crossing of the Little Stour River on the old Roman road east of Canterbury, with a green and pretty cottages. The old water mill still stands by the river. The flint-built church dates from the 15th century, and the churchyard is bounded by a remarkably long thatched barn.

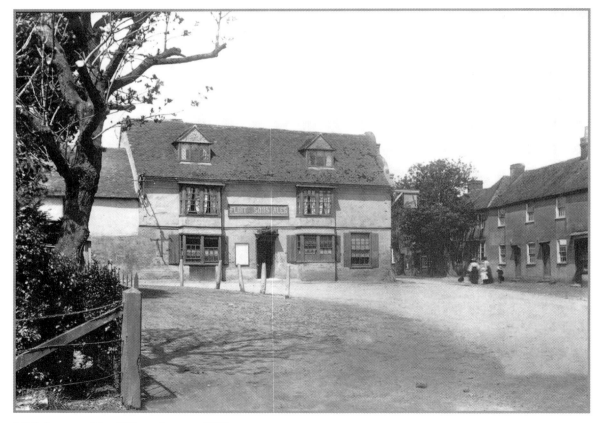

Littlebourne, The Village Square 1903 51052
This sleepy summertime picture shows the village square, deserted save for the little group on the left. The old established Anchor Inn advertises Flint Son's Ales, a local brew.

Leeds Castle

The small village of Leeds is dominated by the presence of its large romantic castle. The castle is Norman, but there was an earlier Saxon castle on the site. The castle remained a royal palace for centuries afterwards, and was left to the nation in 1974. Since then it has become a full-blooded tourist attraction, set in its 500 acre park.

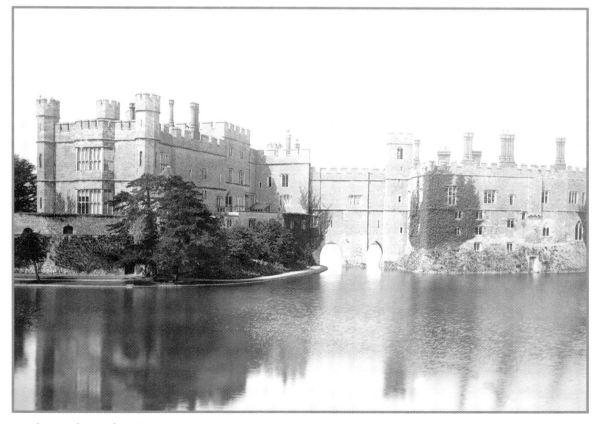

Leeds, Leeds Castle 1892 31500
Leeds Castle rises serenely from its two islands in a lake on the River Len. At this time it was still a private residence, half forgetting its past as a 'queen's castle' and as a prison for 'persons of consequence'.

Maidstone

The county town of Kent stands on the banks of the River Medway. The oldest building, the Bishop's Palace, fronts the river beside the great medieval church of All Saints. Maidstone has been an important market town since the Middle Ages, although today it is also an important industrial centre. Much of its medieval heart survives, including buildings such as the museum.

Left: **Maidstone, High Street c1870** 1480
This photograph shows the drinking fountain and the statue of Queen Victoria, which dates from 1862. To the left is Bank Street, separated from the High Street by a block of buildings - these have infilled the formerly very wide High Street.

Below: **Maidstone, Market Place 1885** 12684
This part of the High Street was Maidstone's market place from early times. The building on the island site with the projecting clock is the Town Hall of 1762-3.

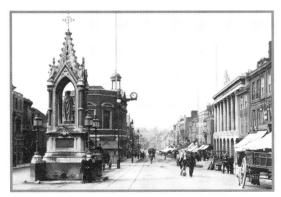

▼ **Maidstone, All Saints Church 1892** 31485
A tranquil scene on the River Medway, looking towards the
magnificent All Saints, Maidstone's parish church, dating from 1395.
It was built largely by Archbishop Courtenay, a great-grandson of
Edward I.

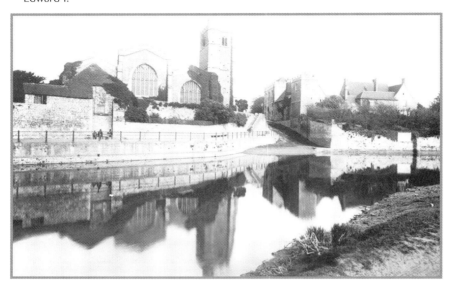

▼ **Maidstone, All Saints Church 1892** 31483
Here we see the River Medway being used as an industrial highway:
barges and log rafts float downstream past the Archbishop's Palace and
All Saints Church. Formerly, a ferry crossed the Medway at this point.

▲ **Maidstone, The
Promenade and Bridge
1898** 41535
This view of the riverside
promenade looks past the
Archbishop's Palace to
Maidstone Bridge and the
chimneys of the industrial
area beyond. Today, St
Peter's Bridge (built in
1978) intervenes
between the palace and
Maidstone Bridge.

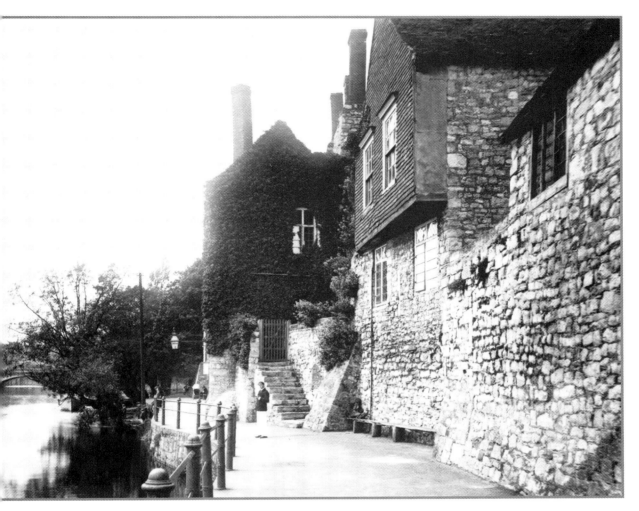

◄ Maidstone, The Museum 1898 41542
This splendid red-brick Tudor house was once Chillington Manor, home of the Wyatts; one of the family, Sir Thomas the younger, led the rebellion against Queen Mary's marriage to Philip of Spain.

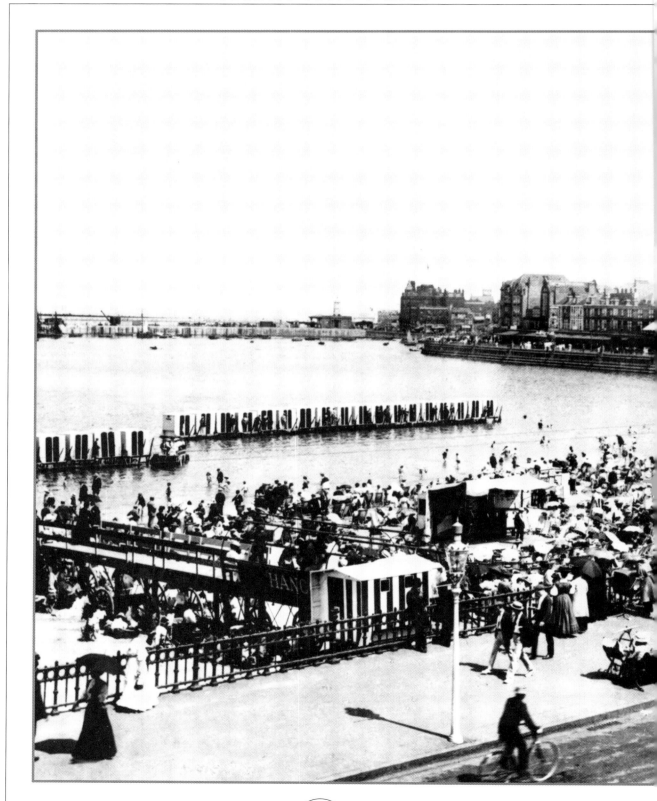

Margate

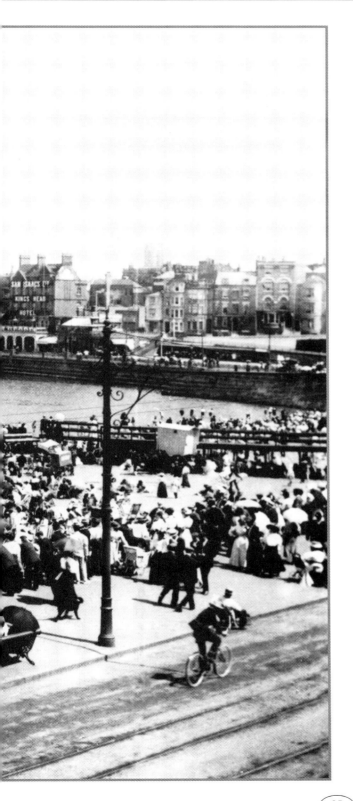

Margate is today a bustling seaside resort on the Isle of Thanet, with many miles of sandy beaches, and typical seaside attractions. Once an old fishing village, it was developed in the mid 1700s as the earliest coastal and seabathing resort. The pier, known as the jetty, has now gone, but the wide sweep of the promenade and harbour remains.

Margate, Marine Parade 1908 60359
This view looks across a crowded beach towards the harbour, the stone pier and the lighthouse. Bathing machines, of which a row can be seen, were invented by Benjamin Beale, a Margate glover, in 1753.

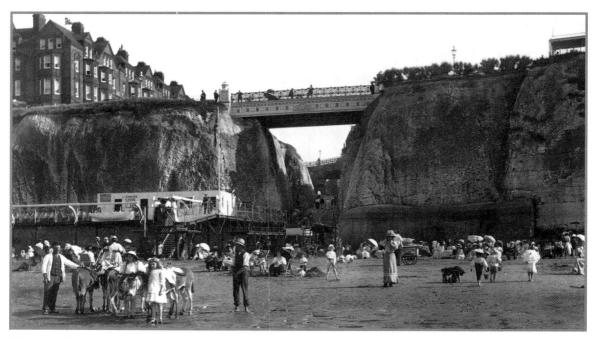

Margate, Newgate Gap 1908 60373
This picture shows the 'new' bridge over Newgate Gap; it was erected in 1907 to replace the original one of 1861.
Below, on the sands of Palm Bay, children build sandcastles and pose with the donkeys.

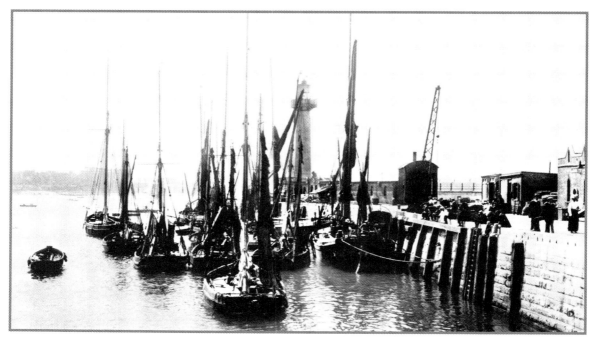

Margate, The Harbour 1908 60370
Thames spritsail barges involved in the coasting trade are moored alongside the stone pier. Coasting and river-
borne traffic frequented the harbour, mooring alongside the 909 ft long pier, which was built in 1815.

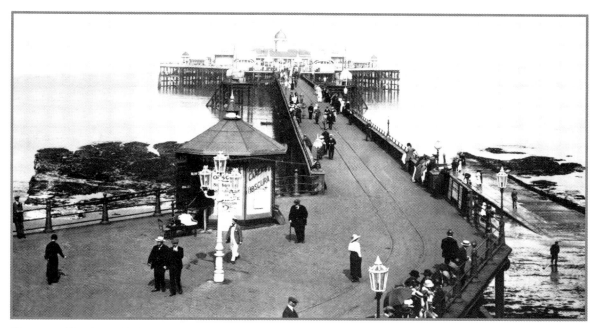

Margate, The Jetty 1918 68444
Margate's jetty (or pier), built in 1855, was destroyed in a storm in 1978, but here we can see the 1,240 ft long structure in its heyday. The jetty extension at the pierhead was an important landing stage, allowing steamships to come alongside even at low water.

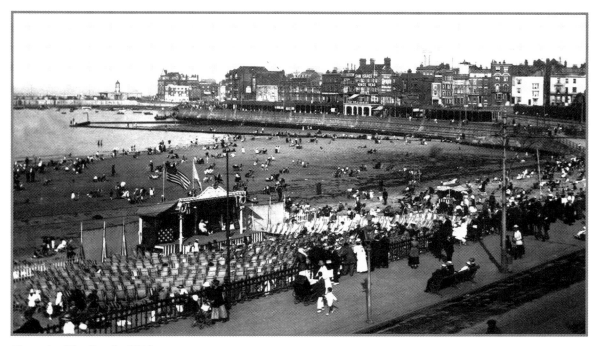

Margate, The Sands 1918 68451
Margate suffered from both bombing and shelling during the First World War, and many people left the town. Nonetheless, it was still possible to take holidays there, as this picture of the famous sands goes to show.

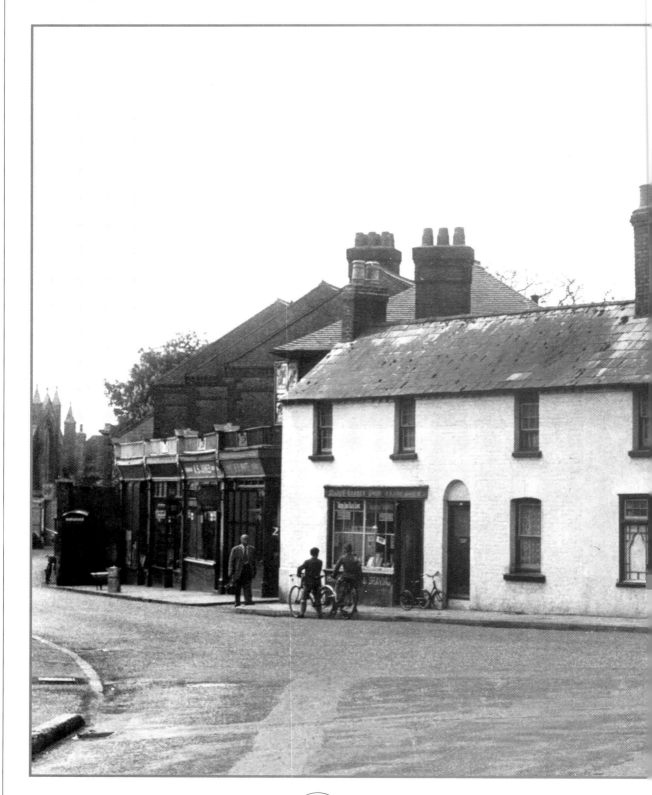

Minster

This is a small village situated in the heart of Thanet, overlooking Minster Marshes. It is well-known for its wonderful old church, which has towers built by the Saxons and Normans. It also has a historic old abbey, now a nunnery, with walls of the old Saxon church.

Left: **Minster, The Square c1955** M86020
Here we see the Square, remarkably free of traffic, in summer sunshine. The famous church is just visible on the extreme left. It is strange to realise that the world's first fatal road accident took place in Minster.

Below: **Minster, The Abbey 1894** 34200
The abbey was founded in AD 670, but the present buildings are Norman - part of a grange of St Augustine's Abbey in Canterbury. It has been a nunnery since 1930.

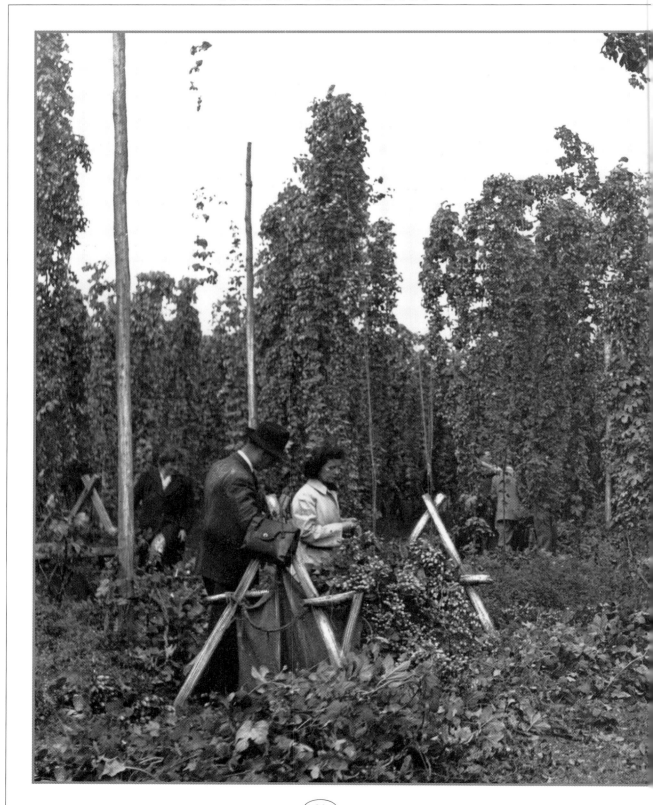

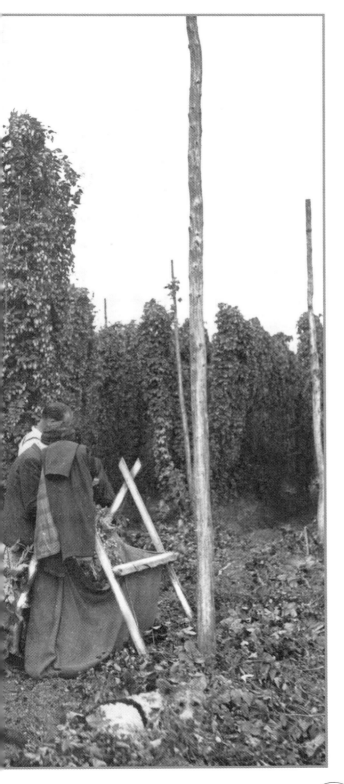

Paddock Wood

Paddock Wood is today a surprisingly modern industrial town. At the centre of the hop-picking area, it was once a great hop centre with many oast houses. Today, its past is commemorated by the Whitbread Hop Farm, the largest hop and oast complex ever built, and now a popular museum.

Left: **Paddock Wood, Hop Picking c1950** P220020
Hops produce long stems each year. These 'bines' are trained up a trellis-work of poles and wires to develop their cones - the part used in brewing. Formerly, the cones were hand-picked by seasonal labourers taking a paid holiday.

Below: **Paddock Wood, Oast Houses c1950**
P220022
These are typical Kentish round oast houses with conical roofs and cowls, used for drying hops. In the early 1900s, over sixty per cent of the hops grown in England were grown in Kent, with 28,169 acres under cultivation in the county in 1907.

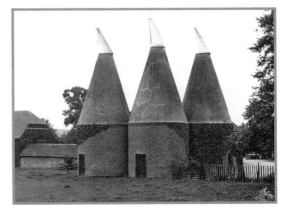

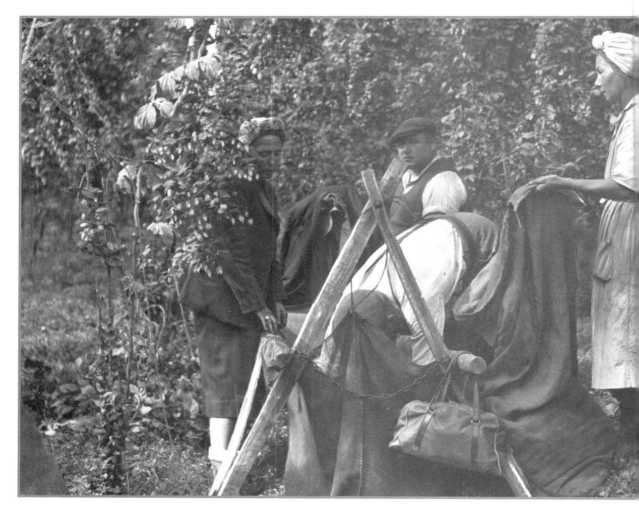

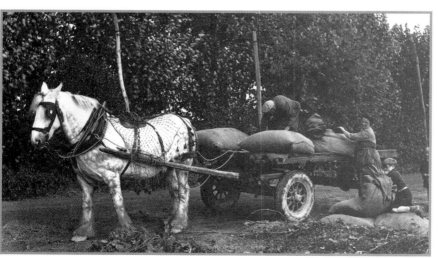

◀ **Paddock Wood, The Hop Harvest c1950**
P220018
Pokes being are loaded onto a horse-drawn wagon for carting to the oasts. The picture, taken at a time when the hopping holiday had virtually disappeared, shows how children as well as adults were involved.

◀ **Paddock Wood, Hop Picking c1950** P220010
The hops are being measured the traditional way. The bags are called 'pokes', and each holds 12 bushels. The man in the centre is probably the tallyman, who was responsible for recording the harvest.

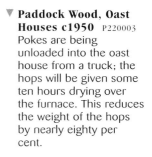

▼ **Paddock Wood, Oast Houses c1950** P220003
Pokes are being unloaded into the oast house from a truck; the hops will be given some ten hours drying over the furnace. This reduces the weight of the hops by nearly eighty per cent.

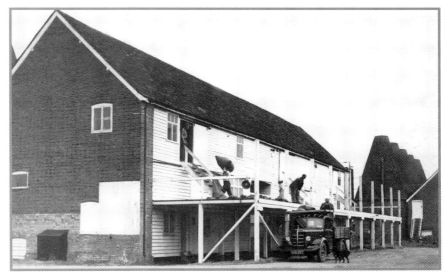

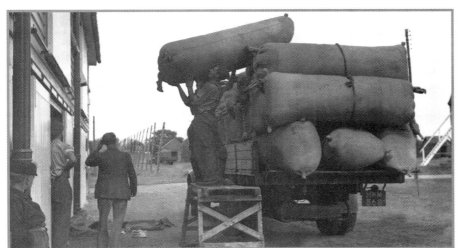

◀ **Paddock Wood, Oast Houses c1950** P220011
The dried hops are done up in 'pockets', each weighing one and a half hundredweight. They are being loaded from the oast house onto a lorry to be taken to market.

Pegwell

Situated at the southernmost part of the Isle of Thanet, the bay is bounded by cliffs on the north, and marshes to the south. Tradition has it that this was the landing-place of both the Danes and of St Augustine.

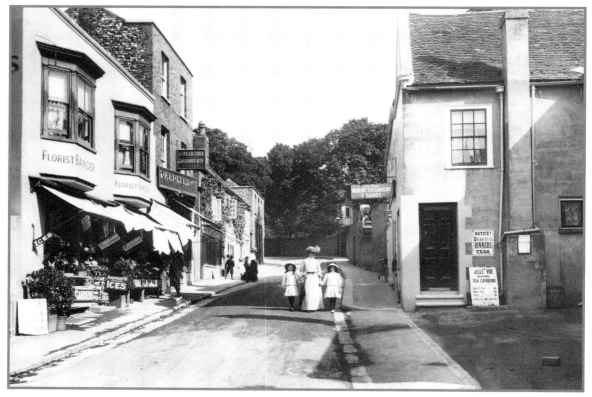

Pegwell, The Village 1907 58296
To the right of this charming view is the entrance to the Belle Vue Tea Gardens, patronised by the young Princess Victoria when she visited with her mother in 1830.

Plaxtol

Plaxtol is a pleasantly-situated hilltop village, with a long main street. There is a lovely group of cottages near the church, which date from the 17th century. The church has many riches, including a hammerbeam roof. There is also a working forge, used for making gates, weathervanes and the like.

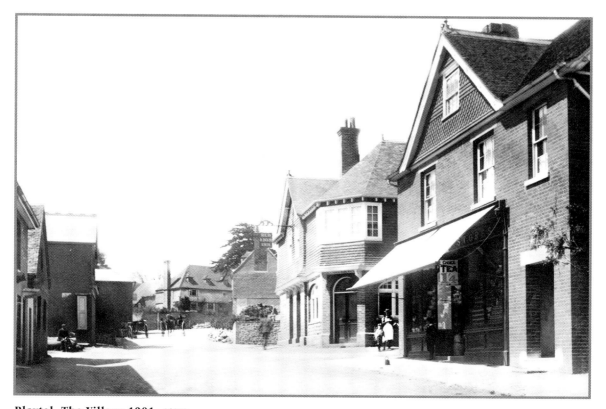

Plaxtol, The Village 1901 46408
The village store stands on the right, and in the centre there is a horsedrawn vehicle. The scene looks surprisingly modern.

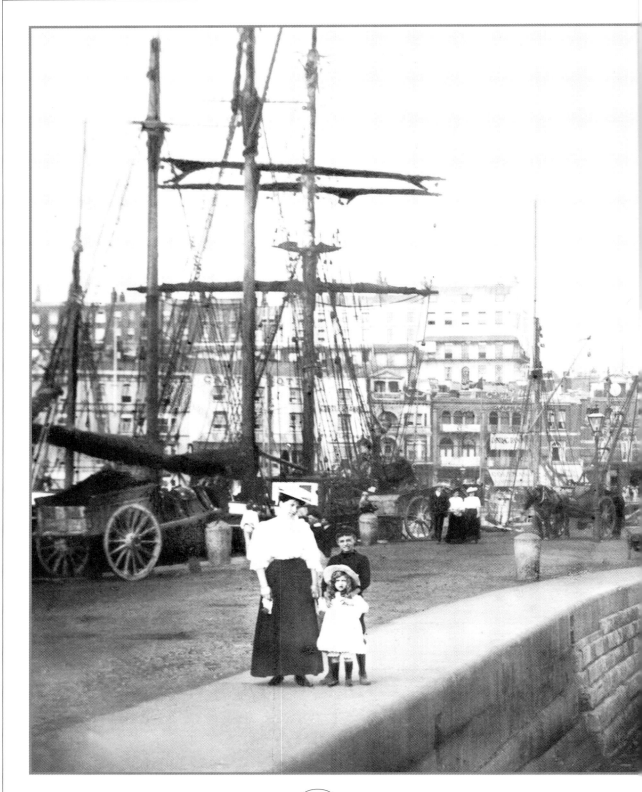

Ramsgate

Ramsgate is a fine resort, fishing village and cross channel harbour all rolled into one. The harbour nestles beneath the steep cliff and steep streets. The medieval church stands high above the promenade, and has a Norman tower. The town has pleasant Georgian terraces, with Victorian development along the promenade.

Ramsgate, The Undercliffe 1907 58287
This prettily posed group stand in the harbour, where a spritsail barge and her boat are moored on the right. On the left, colliers are unloaded. The fishmarket of 1881, demolished in the 1960s, stands in the middle of the picture.

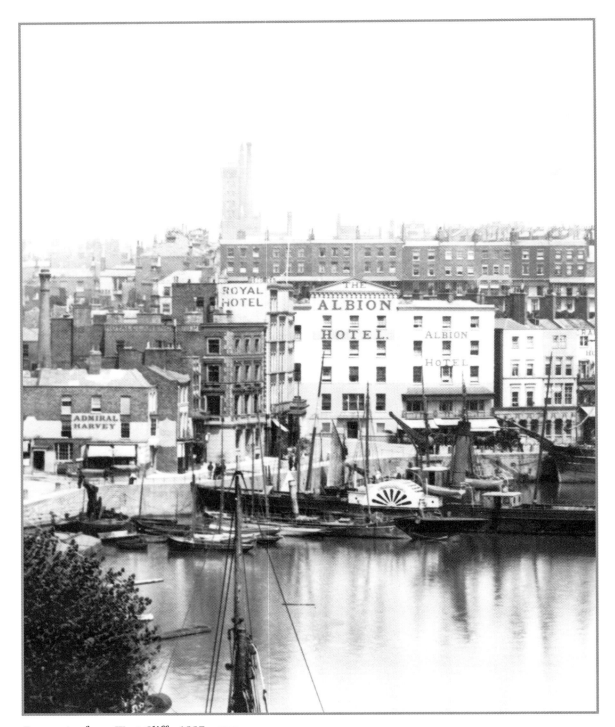

Ramsgate, from West Cliffe 1887 19674A
We are looking to the inner harbour - now the Yacht Marina - from West Cliff. A paddle-steamer and brigs, probably colliers, are moored. The chimney on the left of the Admiral Harvey probably belonged to Ramsgate's first gasworks.

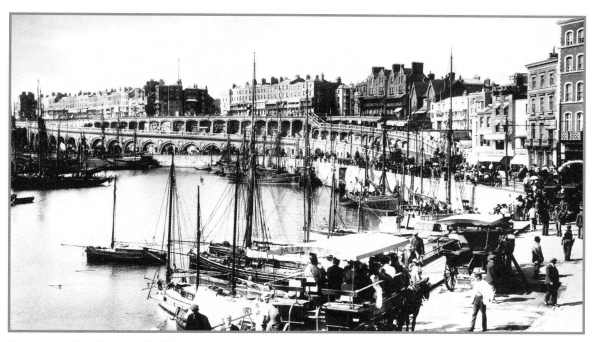

Ramsgate, The Harbour 1901 48028
Part of Ramsgate's famous fleet of fishing smacks are moored in the inner harbour. The horse-drawn brakes in the foreground were used by sightseers - a trip round the harbour was an essential ingredient of a Ramsgate holiday.

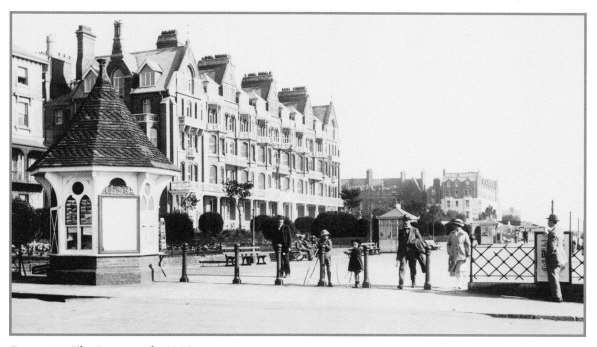

Ramsgate, The Promenade 1918 68463
Children with hoops play on the clifftop promenade, a breezy spot high above the beach. The octagonal building is a newspaper kiosk. Today, the east promenade overlooks the new Ramsgate Port.

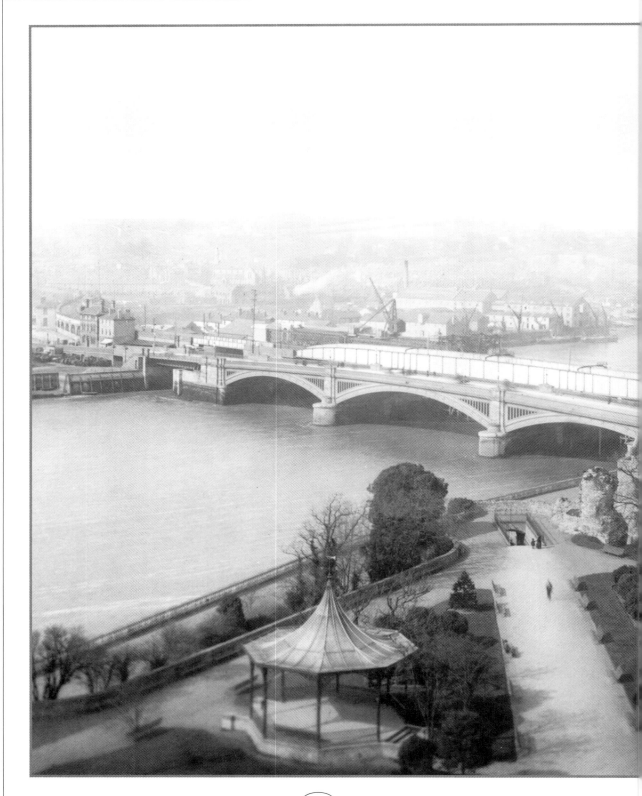

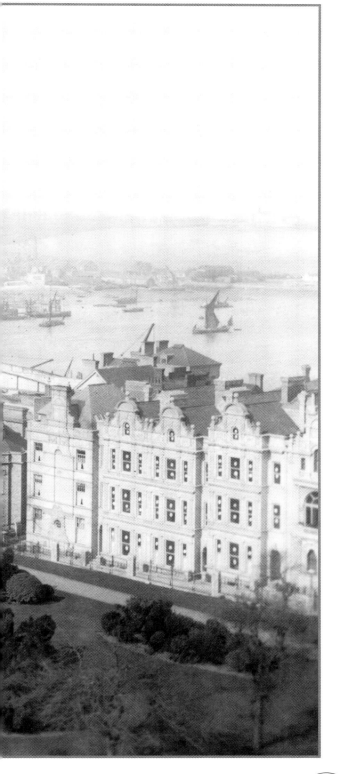

Rochester

Founded by the Romans, where Watling Street bridged the Medway, Rochester has been important for nearly 2,000 years. The cathedral, founded in AD 604, is second only to Canterbury in age. It was rebuilt by the Normans, who also built the castle. The town retains its ancient High Street, with many fine buildings including College Gate. Charles Dickens knew the city well.

Left: **Rochester, The River 1889** 22190
This is the view from Rochester Castle looking across the River Medway. The road and rail bridge were built in 1856; today another bridge, built in 1970, runs alongside it, built with money from the Bridge Trust of 1391.

Below: **Rochester, The Castle 1894** 34035
Here we see the massive Norman keep of Rochester Castle. The castle was first raised soon after 1066, and the impressive keep, the tallest in England, went up in about 1127. The tower of the cathedral is on the left.

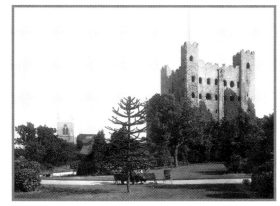

▼ Rochester, The Cathedral 1894 34012

This fascinating view of Rochester Cathedral was taken from the castle. The central tower was rebuilt ten years later, and was crowned with a spire. Beyond is a glimpse of the industrial Medway.

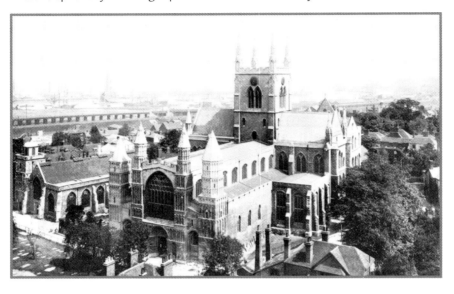

▼ Rochester, The Castle Grounds 1908 59883

The Castle Grounds are dominated by the Norman castle keep. The castle was besieged in 1088, when Bishop Odo fortified it against his nephew, William Rufus. The 1904 spire of the cathedral is on the left.

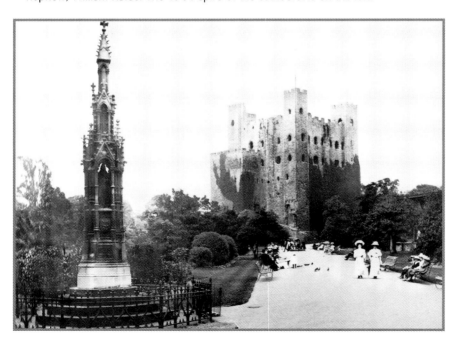

▲ Rochester, High Street 1908 59875

Rochester's High Street runs along the famous Roman Watling Street; it has not changed greatly since this view was taken. The timber-framed house dates from the late 16th century. Opposite is Eastgate House of 1590, now part of the Charles Dickens Centre.

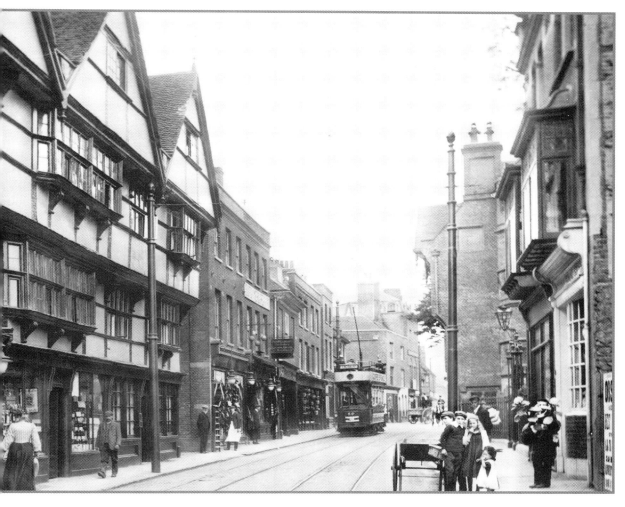

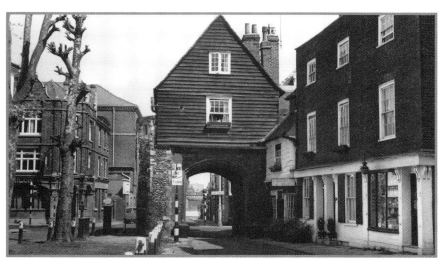

◀ **Rochester, College Gate c1955** R44093
College Gate is one of the three remaining gates leading into the former monastic precinct. It was built in the early 15th century, and is also known as Chertsey's Gate or 'Jasper's Gate', by which name it appears in Dickens' novel 'Edwin Drood'.

Sandwich

Founded by the Saxons, Sandwich was once a Cinque Port at the mouth of the River Stour, but owing to silting it is now two miles from the sea. It reinvented itself as a cloth-weaving town, and is today a quaint market town with narrow streets. The Elizabethan town hall is now the museum. The town retains two of its town gates, Barbican Gate and Fisher Gate.

Sandwich, The Town Hall 1924 76232
Note the open-topped car on the right. The Town Hall originally went up in 1579, but its exterior was completely rebuilt in 1910-12, giving it a mock-Tudor appearance.

Sevenoaks

This is a pleasing country town situated high up on the Weald. Sevenoaks is perhaps best known for the entrance to Knowle Park, built in 1456 and home of the Sackville family since the early 1600s. The High Street is graced by many attractive houses dating from the 17th century, whilst the spacious medieval church is one of the finest in Kent.

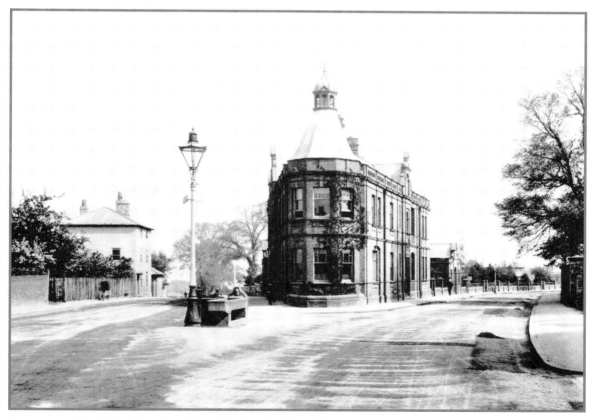

Sevenoaks, The High Street and Constitutional Club 1900 44906
This view shows the Constitutional Club. Note the gas lamp and horse trough in the centre of the picture.

Sevenoaks, The Town 1900 44908
Sevenoaks is the burial place of William Lambarde (1536-1601), author of 'Perambulation of Kent' (1570), the first topographical history of the county.

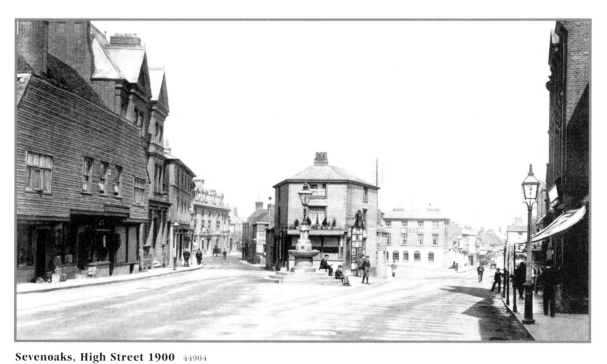

Sevenoaks, High Street 1900 44904
We are looking downhill to where the High Street divides; it continues on as the right-hand fork. The lack of traffic is quite remarkable.

Sheerness

Sheerness. situated on the Isle of Sheppey, is a place of contrasts; it has the docks, and it is a seaside resort. A naval dockyard was founded here by Pepys in the time of Charles II, but it closed in the early 1960s. The promenade, with its gardens and amusements, overlooks the beach and the Thames estuary, with views to Shoeburyness.

Sheerness, The Esplanade c1955 S528048
An impromptu game of football takes place in the shadow of a traditional seaside funfair, as holidaymakers stroll along the Esplanade. The beach, which has subsequently won the European blue flag, lies to the right.

Sissinghurst

This charming village has a delightful main street showing a wide mixture of Kentish houses. Nearby is the ancient gateway to Sissinghurst Castle, which was founded in Tudor times. Today it is owned by the National Trust, and is best known for its gardens designed by Vita Sackville-West.

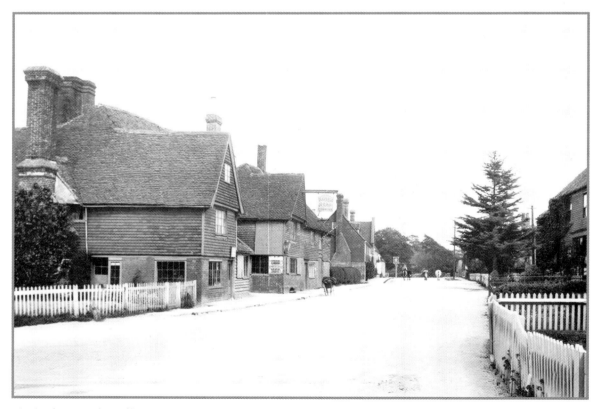

Sissinghurst, The Village 1902 48237
Here we see the type of tile-hung and weatherboarded cottages which abound in this area. The white fencing around the cottage gardens is very typical of villages in the Weald of Kent.

Sittingbourne

An ancient place on Watling Street and the River Swale, Sittingbourne was an important market town, and a stopping-place for Canterbury pilgrims. Today, it is a thriving industrial town, and a centre for paper manufacturing and fruit packing, recalling its position at the heart of the Kentish cherry orchards.

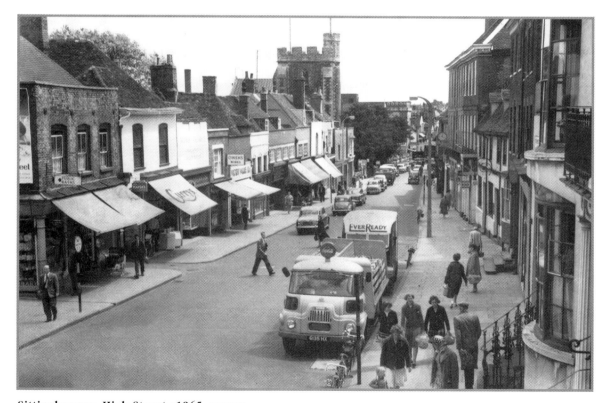

Sittingbourne, High Street c1965 S531058
The busy, bustling High Street runs along the line of the Roman Watling Street. This view shows clearly, when you look above the shopfronts with their various sun-awnings, that the street is lined with a lovely variety of Georgian and earlier architecture.

Stansted

Stansted village is scattered among narrow lanes in the rolling downland north of Wrotham. The church dates from the 14th century, but is built on a Norman site. The two bells are some of the oldest in Kent. There is an exceptional bronze war memorial.

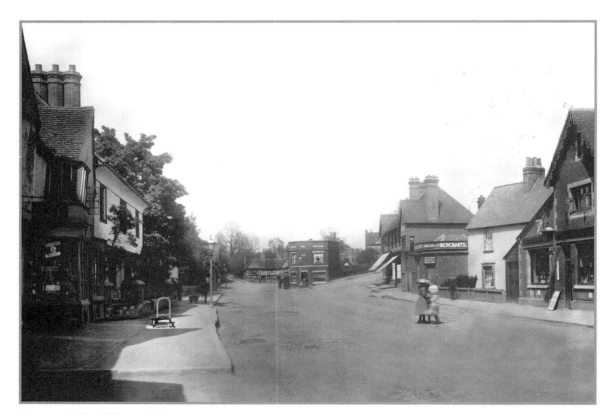

Stansted, The Village 1903 51109
This evocative view of the village centre shows children playing in the street. Today, this view is dominated by the bronze war memorial erected in 1923. It was commissioned in Budapest and shows a man holding a palm branch.

Sturry

A village situated at a crossing of the River Stour, Sturry suffered badly from bomb damage in the Second World War. However, it retains its church, which is Norman in origin, together with its huge tithe barn, built of weatherboard and brick.

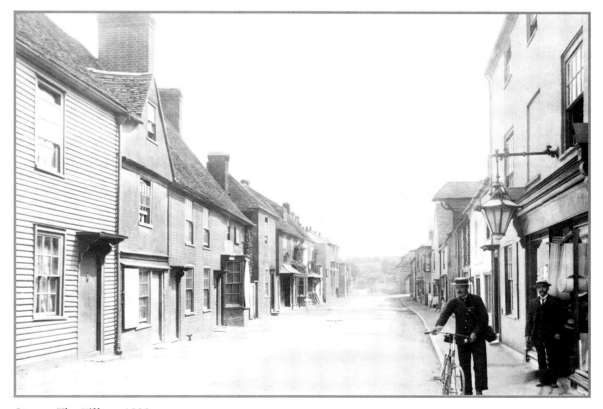

Sturry, The Village 1899 44220
This interesting picture of the village street and the post office shows the village postman about to mount his bicycle. The place-name relates to Sturry's position on the River Stour - 'Stour-y'.

Tenterden

Tenterden is a beautiful old Kentish town close to the Rother Levels. It grew fat in the Middle Ages on sheep, wool and weaving, and later became a market town. Its broad High Street has a pleasing mixture of half-timbered buildings and elegant Regency houses. The fine medieval church has a magnificent 15th-century tower.

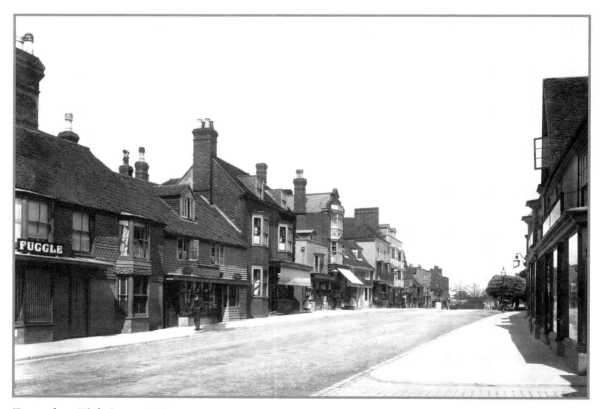

Tenterden, High Street 1900 44992
The impressively wide High Street shows a variety of architectural styles. Tenterden claims to be the birthplace of William Caxton, the first English printer.

Tonbridge

This fine old town is situated at a crossing of the River Medway, which is now spanned by a Victorian cast-iron bridge. Tonbridge has the remains of a Norman castle, which was demolished in the Civil War; only the 13th-century gatehouse remains, and the rest is now gardens. The High Street has many attractive 18th- and 19th-century buildings. Tonbridge is famous for its school, founded in Tudor times.

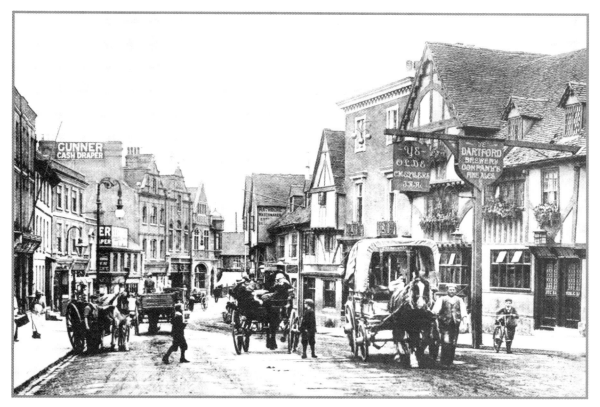

Tonbridge, High Street 1890 T1015004
Horse-drawn wagons are plying the street. The half-timbered Chequers Inn is one of Tonbridge's oldest buildings; it is still there today after nearly being demolished.

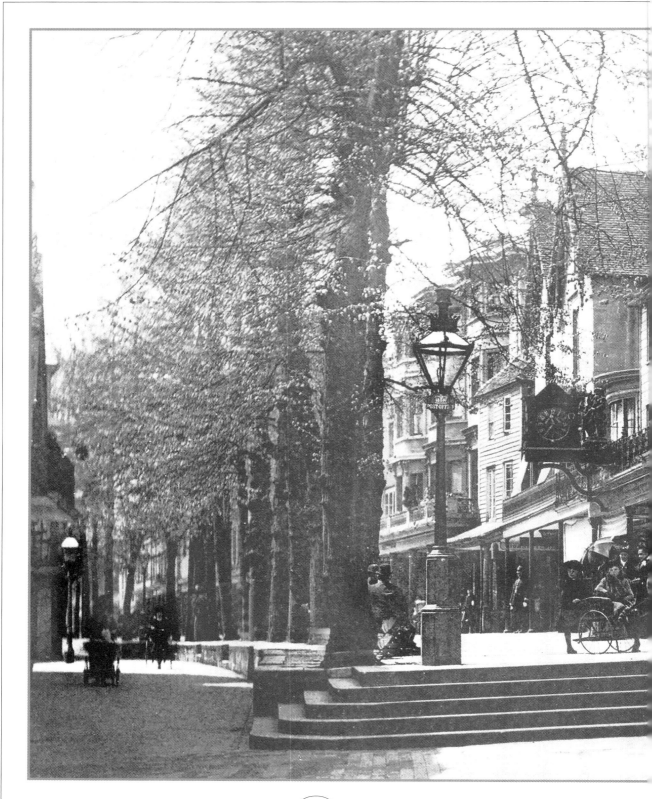

Tunbridge Wells

Tunbridge Wells was once a scattered hamlet in a forested part of the Weald. But in 1606 a chalybeate spring was discovered, and Tunbridge Wells grew into a handsome spa town. Visitors camped on the common until building began; in 1638 a promenade called the Walk was laid out. The Walk was paved, and became the Pantiles.

Tunbridge Wells, The Pantiles c1890 T87001
The most famous landmark of the Wells is the Pantiles, a terraced walk with rather superior shops behind a colonnade, flanked by limes. This was originally laid out as the Walk, and only later was it tiled.

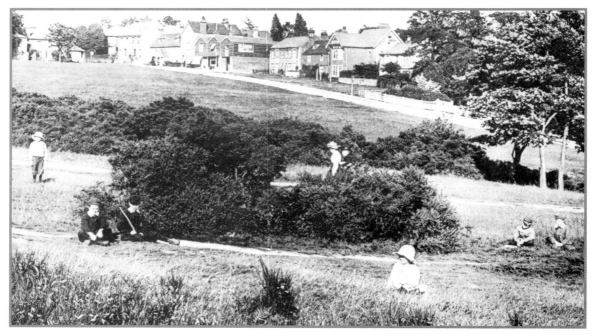

Tunbridge Wells, Southborough Common 1890 T875010
This is a wonderfully evocative view of Southborough Common. The common has long been a favourite place for recreation, and the children are posing attentively for the photographer.

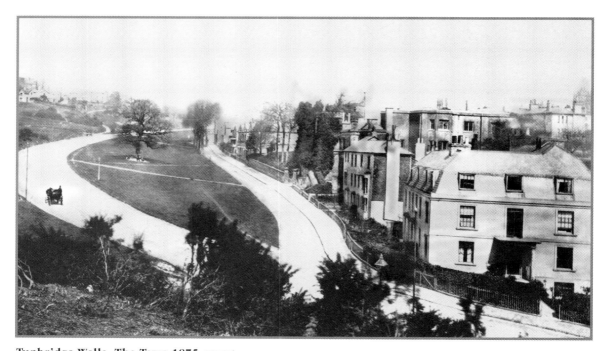

Tunbridge Wells, The Town 1875 T87006
This is an early view of Tunbridge Wells, with a lone cart ascending the hill beside the common, where early visitors like Queen Henrietta Maria had camped. The view is unmistakable, even today.

Willesborough

Willesborough is an old village, with a medieval church thought to be built on Saxon foundations. Its attractive white-boarded smock mill looks down towards the church. Today, the village is a suburb of Ashford, and is carved in two by the M20 motorway.

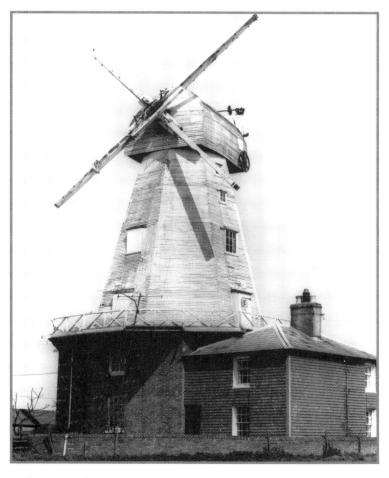

Willesborough, The Windmill c1955 W101002
A delightful close-up view of a typical Kentish windmill; this one is an octagonal white-boarded smock mill. The mill was built in 1869.

Frith Book Co Titles

Frith Book Company publish over 100 new titles each year. For latest catalogue please contact Frith Book Co.

Town Books 96pp, 100 photos. County and Themed Books 128pp, 150 photos
(unless specified) All titles hardback laminated case and jacket
except those indicated pb (paperback)

Around Bakewell	1-85937-113-2	£12.99	Isle of Man	1-85937-065-9	£14.99
Around Barnstaple	1-85937-084-5	£12.99	Isle of Wight	1-85937-114-0	£14.99
Around Bath	1-85937-097-7	£12.99	Around Leicester	1-85937-073-x	£12.99
Around Blackpool	1-85937-049-7	£12.99	Around Lincoln	1-85937-111-6	£12.99
Around Bognor Regis	1-85937-055-1	£12.99	Around Liverpool	1-85937-051-9	£12.99
Around Bournemouth	1-85937-067-5	£12.99	Around Maidstone	1-85937-056-X	£12.99
Around Bristol	1-85937-050-0	£12.99	North Yorkshire	1-85937-048-9	£14.99
British Life A Century Ago	1-85937-103-5	£17.99	Northumberland and Tyne & Wear		
Around Cambridge	1-85937-092-6	£12.99		1-85937-072-1	£14.99
Cambridgeshire	1-85937-086-1	£14.99	Around Nottingham	1-85937-060-8	£12.99
Cheshire	1-85937-045-4	£14.99	Around Oxford	1-85937-096-9	£12.99
Around Chester	1-85937-090-X	£12.99	Oxfordshire	1-85937-076-4	£14.99
Around Chesterfield	1-85937-071-3	£12.99	Around Penzance	1-85937-069-1	£12.99
Around Chichester	1-85937-089-6	£12.99	Around Plymouth	1-85937-119-1	£12.99
Cornwall	1-85937-054-3	£14.99	Around Reading	1-85937-087-X	£12.99
Cotswolds	1-85937-099-3	£14.99	Around St Ives	1-85937-068-3	£12.99
Cumbria	1-85937-101-9	£14.99	Around Salisbury	1-85937-091-8	£12.99
Around Derby	1-85937-046-2	£12.99	Around Scarborough	1-85937-104-3	£12.99
Devon	1-85937-052-7	£14.99	Scottish Castles	1-85937-077-2	£14.99
Dorset	1-85937-075-6	£14.99	Around Sevenoaks and Tonbridge		
Dorset Coast	1-85937-062-4	£14.99		1-85937-057-8	£12.99
Down the Thames	1-85937-121-3	£14.99	Sheffield and S Yorkshire	1-85937-070-5	£14.99
Around Dublin	1-85937-058-6	£12.99	Around Southport	1-85937-106-x	£12.99
East Anglia	1-85937-059-4	£14.99	Around Shrewsbury	1-85937-110-8	£12.99
Around Eastbourne	1-85937-061-6	£12.99	Shropshire	1-85937-083-7	£14.99
English Castles	1-85937-078-0	£14.99	South Devon Coast	1-85937-107-8	£14.99
Essex	1-85937-082-9	£14.99	Staffordshire (96pp)	1-85937-047-0	£12.99
Around Exeter	1-85937-126-4	£12.99	Around Stratford upon Avon		
Around Falmouth	1-85937-066-7	£12.99		1-85937-098-5	£12.99
Around Great Yarmouth	1-85937-085-3	£12.99	Suffolk	1-85937-074-8	£14.99
Greater Manchester	1-85937-108-6	£14.99	Surrey	1-85937-081-0	£14.99
Hampshire	1-85937-064-0	£14.99	Around Torbay	1-85937-063-2	£12.99
Around Harrogate	1-85937-112-4	£12.99	Welsh Castles	1-85937-120-5	£14.99
Hertfordshire	1-85937-079-9	£14.99	West Midlands	1-85937-109-4	£14.99
			Wiltshire	1-85937-053-5	£14.99

Frith Book Co Titles Available in 2000

Canals and Waterways	1-85937-129-9	£17.99	Apr
Around Guildford	1-85937-117-5	£12.99	Apr
Around Horsham	1-85937-127-2	£12.99	Apr
Around Ipswich	1-85937-133-7	£12.99	Apr
Ireland (pb)	1-85937-181-7	£9.99	Apr
London (pb)	1-85937-183-3	£9.99	Apr
New Forest	1-85937-128-0	£14.99	Apr
Around Newark	1-85937-105-1	£12.99	Apr
Around Newquay	1-85937-140-x	£12.99	Apr
Scotland (pb)	1-85937-182-5	£9.99	Apr
Around Southampton	1-85937-088-8	£12.99	Apr
Sussex (pb)	1-85937-184-1	£9.99	Apr
Around Winchester	1-85937-139-6	£12.99	Apr
Around Belfast	1-85937-094-2	£12.99	May
Colchester (pb)	1-85937-188-4	£8.99	May
Dartmoor	1-85937-145-0	£14.99	May
Exmoor	1-85937-132-9	£14.99	May
Leicestershire (pb)	1-85937-185-x	£9.99	May
Lincolnshire	1-85937-135-3	£14.99	May
North Devon Coast	1-85937-146-9	£14.99	May
Nottinghamshire (pb)	1-85937-187-6	£9.99	May
Peak District	1-85937-100-0	£14.99	May
Redhill to Reigate	1-85937-137-x	£12.99	May
Around Truro	1-85937-147-7	£12.99	May
Yorkshire (pb)	1-85937-186-8	£9.99	May
Berkshire (pb)	1-85937-191-4	£9.99	Jun
Brighton (pb)	1-85937-192-2	£8.99	Jun
Churches of Berkshire	1-85937-170-1	£17.99	Jun
Churches of Dorset	1-85937-172-8	£17.99	Jun
Derbyshire (pb)	1-85937-196-5	£9.99	Jun
East Sussex	1-85937-130-2	£14.99	Jun
Edinburgh (pb)	1-85937-193-0	£8.99	Jun
Norwich (pb)	1-85937-194-9	£8.99	Jun
South Devon Living Memories			
	1-85937-168-x	£14.99	Jun

Stone Circles & Ancient Monuments			
	1-85937-143-4	£17.99	Jun
Victorian & Edwardian Kent			
	1-85937-149-3	£14.99	Jun
Warwickshire (pb)	1-85937-203-1	£9.99	Jun
Buckinghamshire (pb)	1-85937-200-7	£9.99	Jul
Down the Severn	1-85937-118-3	£14.99	Jul
Kent (pb)	1-85937-189-2	£9.99	Jul
Victorian & Edwardian Yorkshire			
	1-85937-154-x	£14.99	Jul
West Sussex	1-85937-148-5	£14.99	Jul
Cornish Coast	1-85937-163-9	£14.99	Aug
County Durham	1-85937-123-x	£14.99	Aug
Croydon Living Memories	1-85937-162-0	£12.99	Aug
Dorsert Living Memories	1-85937-210-4	£14.99	Aug
Glasgow (pb)	1-85937-190-6	£8.99	Aug
Gloucestershire	1-85937-102-7	£14.99	Aug
Herefordshire	1-85937-174-4	£14.99	Aug
Kent Living Memories	1-85937-125-6	£14.99	Aug
Lancashire (pb)	1-85937-197-3	£9.99	Aug
Manchester (pb)	1-85937-198-1	£8.99	Aug
North London	1-85937-206-6	£14.99	Aug
Somerset	1-85937-153-1	£14.99	Aug
Tees Valley & Cleveland	1-85937-211-2	£14.99	Aug
Worcestershire	1-85937-152-3	£14.99	Aug
Victorian & Edwardian Maritime Album			
	1-85937-144-2	£17.99	Aug

Available from your local bookshop or from the publisher

FRITH PRODUCTS & SERVICES

Francis Frith would doubtless be pleased to know that the pioneering publishing venture he started in 1860 still continues today. More than a hundred and thirty years later, The Francis Frith Collection continues in the same innovative tradition and is now one of the foremost publishers of vintage photographs in the world. Some of the current activities include:

Interior Decoration

Today Frith's photographs can be seen framed and as giant wall murals in thousands of pubs, restaurants, hotels, banks, retail stores and other public buildings throughout the country. In every case they enhance the unique local atmosphere of the places they depict and provide reminders of gentler days in an increasingly busy and frenetic world.

Product Promotions

Frith products have been used by many major companies to promote the sales of their own products or to reinforce their own history and heritage. Brands include Hovis bread, Courage beers, Scots Porage Oats, Colman's mustard, Cadbury's foods, Mellow Birds coffee, Dunhill pipe tobacco, Guinness, and Bulmer's Cider.

Genealogy and Family History

As the interest in family history and roots grows world-wide, more and more people are turning to Frith's photographs of Great Britain for images of the towns, villages and streets where their ancestors lived; and, of course, photographs of the churches and chapels where their ancestors were christened, married and buried are an essential part of every genealogy tree and family album.
A series of easy-to-use CD Roms is planned for publication, and an increasing number of Frith photographs will be able to be viewed on specialist genealogy sites. A growing range of Frith books will be available on CD.

Frith Products

All Frith photographs are available Framed or just as Mounted Prints, and can be ordered from the address below. From time to time other products - Address Books, Calendars, Table Mats, etc - are available.

The Internet

Already thousands of Frith photographs can be viewed and purchased on the internet. By the end of the year 2000 some 60,000 Frith photographs will be available on the internet. The number of sites is constantly expanding, each focussing on different products and services from the Collection.
Some of the sites are listed below.
www.townpages.co.uk
www.icollector.com
www.barclaysquare.co.uk
www.cornwall-online.co.uk

For more detailed information on Frith companies and products, look at these sites:
www.francisfrith.co.uk
www.frithbook.co.uk
www.francisfrith.com

See the complete list of Frith Books at:

www.frithbook.co.uk

This web site is regularly updated with the latest list of publications from the Frith Book Company Ltd. If you wish to buy books relating to another part of the country that your local bookshop does not stock, you may purchase on-line.

For further information, trade, or author enquiries please contact us at the address below:
The Francis Frith Collection, Frith's Barn, Teffont, Salisbury, Wiltshire, England SP3 5QP.
Tel: +44 (0)1722 716 376 Fax: +44 (0)1722 716 881 Email: uksales@francisfrith.com

To receive your FREE Mounted Print

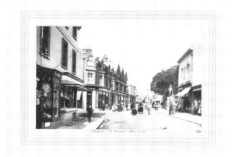

Mounted Print
Overall size 14 x 11 inches

Cut out this Voucher and return it with your remittance for £1.50 to cover postage and handling.
Choose any photograph included in this book. Your SEPIA print will be A4 in size, and mounted in a cream mount with burgundy rule lines, overall size 14 x 11 inches.

Order additional Mounted Prints at HALF PRICE (only £7.49 each*)

If there are further pictures you would like to order, possibly as gifts for friends and family, acquire them at half price (no additional postage and handling required).

Have your Mounted Prints framed*

For an additional £14.95 per print you can have your chosen Mounted Print framed in an elegant polished wood and gilt moulding, overall size 16 x 13 inches (no additional postage and handling required).

> *** IMPORTANT!**
> These special prices are only available if ordered using the original voucher on this page (no copies permitted) and at the same time as your free Mounted Print, for delivery to the same address

Frith Collectors' Guild

From time to time we publish a magazine of news and stories about Frith photographs and further special offers of Frith products. If you would like 12 months FREE membership, please return this form.

Send completed forms to:
The Francis Frith Collection, Frith's Barn, Teffont, Salisbury, Wiltshire SP3 5QP

Voucher for FREE and Reduced Price Frith Prints

Picture no.	Page number	Qty	Mounted @ £7.49	Framed + £14.95	Total Cost
		1	**Free of charge***	£	£
			£7.49	£	£
			£7.49	£	£
			£7.49	£	£
			£7.49	£	£
			£7.49	£	£

Please allow 28 days for delivery * Post & handling £1.50

Book Title **Total Order Cost** £

Please do not photocopy this voucher. Only the original is valid, so please cut it out and return it to us.

I enclose a cheque / postal order for £
made payable to 'The Francis Frith Collection'
OR please debit my Mastercard / Visa / Switch / Amex card

Number .

Expires Signature .

Name Mr/Mrs/Ms .

Address .

. .

. .

. Postcode

Daytime Tel No . Valid to 31/12/01

The Francis Frith Collectors' Guild

Please enrol me as a member for 12 months free of charge.

Name Mr/Mrs/Ms .

Address .

. .

. .

. Postcode